The Lapp King's Daughter

The Lapp King's Daughter

A FAMILY'S JOURNEY
THROUGH FINLAND'S WARS

❧

Stina Katchadourian

2010 · FITHIAN PRESS, McKINLEYVILLE, CALIFORNIA

With deep gratitude to
The Finlandia Foundation
Helen Bing
Finlands Svenska Författareförening

Maps by Johanna Roto

The interior design and the cover design of this book are intended for and limited to the publisher's first print edition of the book and related marketing display purposes. All other use of those designs without the publisher's permission is prohibited.

Published by Fithian Press
A division of Daniel and Daniel, Publishers, Inc.
Post Office Box 2790
McKinleyville, CA 95519
www.danielpublishing.com

Distributed by SCB Distributors (800) 729–6423

LIBRARY OF CONGRESS CATALOGING-IN-PUBLICATION DATA
Katchadourian, Stina.
 The Lapp king's daughter : a family's journey through Finland's wars / by Stina Katchadourian.
 p. cm.
 ISBN 978-1-56474-498-2
 1. Katchadourian, Stina—Childhood and youth. 2. Katchadourian, Stina—Family. 3. Lindfors, Lale—Correspondence. 4. Lindfors, Nunni, 1904–1987—Correspondence. 5. Russo-Finnish War, 1939–1940—Personal narratives, Finnish. 6 World War, 1939–1945—Personal narratives, Finnish. 7. World War, 1939–1945—Finland. 8. World War, 1939–1945—Lapland. 9. Lapland—History—20th century. 10. Finland—Biography. I. Title.
 DL1102.5.K38 2010
 940.53'489770922—dc22
 2009050523

To the memory of my parents,

Nunni and Lale

ACKNOWLEDGEMENTS

During the writing of this book, my older sister, Maj, provided me with the same unflagging support she showed her little sister during the dramatic war years. Her excellent recall of events, replete with sensory details, has gone a long way to help me remember more clearly myself, as well as gain an even deeper appreciation of what our parents, Nunni and Lale, lived through. I owe her a deep debt of gratitude.

Many friends offered valuable insights and comments. They have meant the world to me in showing me that my intensely private experience could hold their interest. Ann Davidson, Marilyn Yalom, and Nancy Packer spent many hours in close reading of the manuscript and in conversations with me, and I have greatly benefited from their advice and support throughout the process. Susan Groag Bell was an early reader of the manuscript whose European perspective was of great help. Birgitta Boucht in Finland gave the manuscript a careful reading and has been a great support throughout.

This is to a large extent the story of one family's experiences during the war years. I have been fortunate to have many relatives and friends in Finland to talk to and remember with. Foremost of these is my cousin, Ulf Krause, whose careful reading of the manuscript and help with many details of family history have been invaluable to me. My sincere thanks also go to two other cousins, Teddy Holmström and Adi Janson, for their help with photographs and family lore. My childhood friend Merete

Graae, with whom I shared many nights in the bomb shelter, also helped with memories of her own, as did Ulla Virkkunen, who was with us on the painful train ride back home to Helsinki through our war-torn country.

My warmest thanks also go to Professor Mikko Majander of Helsinki University and Dr. Thomas Westerbom, who took time out of their busy schedules to give the manuscript a careful reading. If any errors of history still remain, they are entirely my own fault.

It would never have been possible for me to carve out the time and space in my life necessary to go through my parents' correspondence—dating from 1926 to 1945—that form a large part of this book, if it had not been for a Fellowship at the McDowell Colony in New Hampshire. To be able to spread out papers and leave them undisturbed and to be able to look forward to hours of uninterrupted time with a lunch basket deposited on your doorstep—this surely is a version of heaven for any writer.

The Information Center for Finnish Literature provided me with a grant for which I am deeply grateful. It enabled me to spend time in archives in Stockholm, in Lapland, and in Helsinki. I want to thank archivists Maret Vehmaa and Päivi Vestola at the Finnish Military Archives in Helsinki, archivist Arja Moilanen at the Provincial Museum in Rovaniemi, Finland, and Anders Degerström at the Royal Swedish War Archives in Stockholm, Sweden for all their help.

My editors, John Daniel and Susan Daniel, were pure pleasure to work with, and have my heartfelt gratitude.

Last but not least, I want to thank my husband, Herant, who managed to offer helpful suggestions and to be interested in my writing while working on a book of his own.

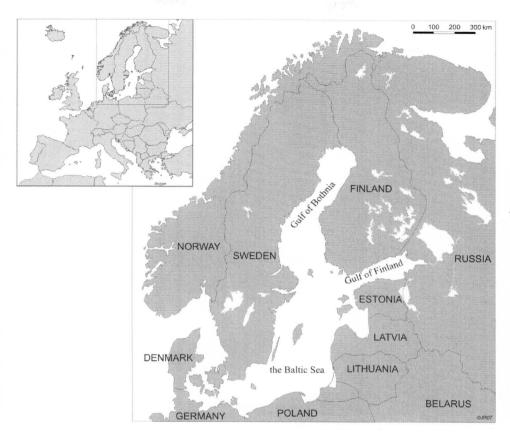

Europe during World War II

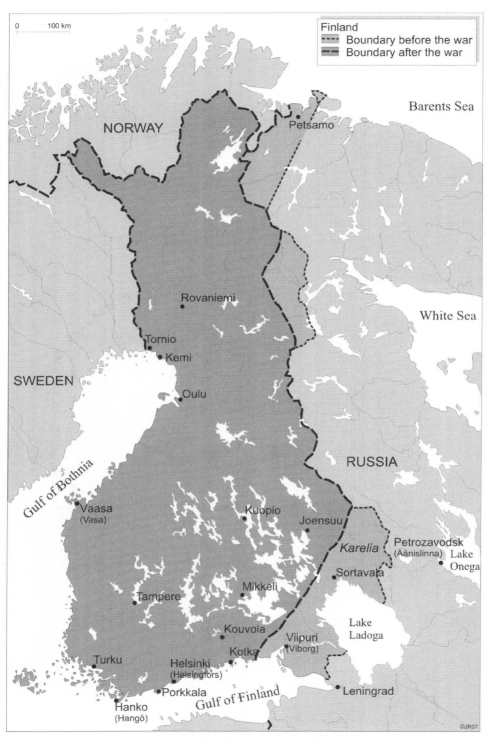

Names in parentheses are Swedish names

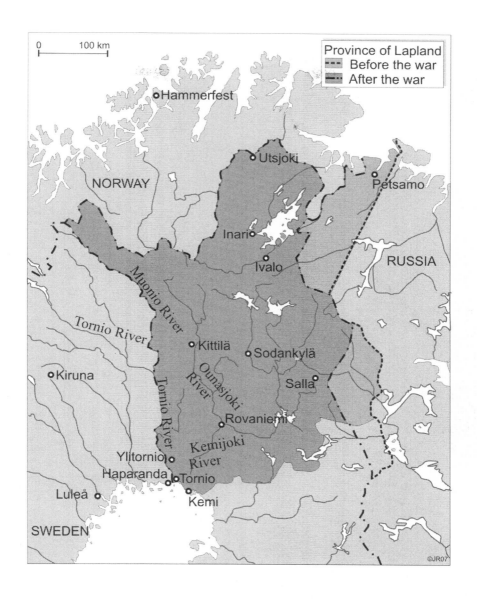

Contents

A section of photographs follows page 88

The Letters

W HEN MY FATHER, Lale, fell in love with my mother, it caused him to question his sanity. There she was, the sparkling and vivacious Nunni, a university student, waltzing in and out of the Helsinki apartment he shared with his best friend, his fellow forestry student, Gunnar, to whom she was engaged.

This makes absolutely no sense, he told himself as Nunni and Gunnar set a date for their wedding. I'm a rational person and this makes no sense. Gunnar, in a state of bliss and entirely unaware of his best friend's feelings, asked Lale to be his best man. Stoically, he accepted, and prepared himself for the day he would have to watch Nunni walk down the aisle, toward him, but into Gunnar's arms.

But that day never came. Three months before the wedding, Gunnar came down with a high fever. Two days later, he was dead. From best man, Lale now was the shoulder Nunni cried on, and the person to whom she poured out her grief.

My mother kept a gold locket with a delicate lid that opened to show Gunnar's picture. Although she never made me doubt that she loved my father deeply, she would occasionally talk about Gunnar, and she would end those conversations by saying, One day you'll know much more.

That moment came on a cold February day in 1996, nine

years after my mother's death and sixty years after my parents'
wedding. Ahead of me was a month at an artist's retreat in
New Hampshire. On the table in my little house in the woods
overlooking a snow-covered meadow were two large packages
wrapped in sturdy brown paper labeled in my mother's hand:
"Letters from Nunni to Lale" and "Letters from Lale to Nunni,
1926–1945." I had waited two days, walking around that mead-
ow, before I could bring myself to open them.

The packages had been wrapped with the characteristic care
my father put into those things. Paper corners folded at the
same angles and the string in tidy knots. The packages contained
a number of gray folders, one folder for every ten years of letters.
The letters themselves were arranged, inside these folders and
out of their envelopes, in chronological order. My father had
been in agreement with my mother about sharing these letters
with my sister and me.

It took me the whole month to read my parents' dialogue,
the best gift they ever gave me.

∾

My mother grew up in the Finnish countryside. The youngest of
Frans and Hildur Blomqvist's three children, she enjoyed a care-
free childhood in the small paper mill community of Kaukas in
eastern Finland, where her father was an engineer. In 1904, the
year she was born, Finland was not yet an independent coun-
try but rather, since 1809, a Grand Duchy under Tsarist Russia.
Before then, for several hundred years, the country had been
a province under the Swedish crown. During that time, some
Swedish-speaking people had been moving east to live in the
Finnish province. Both my parents were members of this lin-
guistic minority, who consider Finland to be their country but
who have retained their Swedish language. Today, in a country
that is officially bilingual, close to six percent of the popula-
tion has Swedish as their first language. At the time of Nunni's
birth the Swedish Finns, although represented at all levels of

society, still had a relatively larger portion of educated and well-off people than the majority Finnish-speaking population. The community where she grew up reflected this fact: the workers were Finnish-speaking, while most of the administrative and technical people spoke Swedish.

There was an elementary school in Kaukas, but my grandparents would have found it unthinkable to send their children there: the language of instruction was Finnish. Instead, a governess was brought in from Helsinki (which they referred to as Helsingfors, in Swedish), and Nunni, her older brother, Torolf, and sister Birgit (Biggi), were educated at home. But their playmates were the children of paper mill workers, and Finnish was the language they played in.

Her idyllic childhood came to an abrupt end with the Finnish civil war of 1918. This tragedy came on the heels of Finland's declaration of independence during the turmoil of the 1917 Russian Revolution. The brutal civil war lasted only three months but was eventually to claim 30,000 victims. It pitted the rising working-class left, the Reds, against the White bourgeoisie aided by Imperial Germany. My mother saw the fathers of some of her playmates marched away to be shot. Judging life at Kaukas too risky, my grandfather took his family away to Helsinki. As it turned out, he took them from the frying pan into the fire: for a while, Helsinki was in the hands of the Reds. My mother was fourteen years old, a country girl with long braids, when she first started regular school.

By the time my mother met Gunnar, her family in Helsinki was in dire financial straits. My grandmother tried running a charcuterie; my grandfather peddled various inventions. Both efforts met with meager results. Nunni needed a profession quickly; her dreams of becoming a painter had to give way to the safer career of a physiotherapist and teacher of physical education.

ev

My paternal grandfather, Uno Lindfors, was an officer in the Finnish military, stationed in Vaasa (we called it Vasa) where he met and married my Grandma Nanny. His was a risky career in the Grand Duchy of Finland, where most Finnish institutions were subject to increasing Russian repression. In March 1899, one of his brothers was invited to join a delegation of 500 prominent citizens going to St. Petersburg with a petition for Tsar Nicholas II, asking him to respect Finnish fundamental laws and self-rule. Over half a million Finns, close to half the adult population, had signed this document. The Tsar refused to receive them, but he let them know—and I can still hear my Grandma Nanny's indignant voice as she told me the story—that "he was not angry." "We were only asking for our rights," she used to say, "and the Tsar treated us as children." When the Finnish army, on Tsarist orders, was disbanded, Grandpa Uno lost his job and went to work as chief accountant in a Vaasa cotton mill. He died before my father, the eldest of the three Lindfors children, graduated from high school. Grandma Nanny inherited her husband's job.

Money was tight and my father too needed to get a profession fast. Fortunately, he was able to study what really interested him: forestry. He was well into his studies at Helsinki University in 1918 when the Finnish Civil War broke out. A precocious twenty-year-old, he joined the White army and nearly lost his life in a battle when a bullet grazed his arm, just inches from his heart. He was caught by the Reds and spent months imprisoned in a Helsinki school. By the time of his graduation from Helsinki University in 1920 he had already, through his friend and fellow student Gunnar, made my mother's acquaintance.

<center>℘</center>

After Gunnar died, there was nothing for my father to do but wait. Selflessly and patiently, he waited while Nunni tried her best to be honest with him. Her grief was still overwhelming, her feelings raw, and from time to time she plunged into deep

depression. She hid nothing from him, or he from her, in their frequent letters.

"Please forgive me," she wrote from a summer camp for children where she worked, "but sometimes it feels like the children are stomping on my heart with their sandy shoes. Please remember, Lale, I always want to be honest with you. I've been feeling lost for so long, and you have helped me find my way. At first, I was very frightened and I remember crying myself to sleep when I noticed that you cared for me, but I didn't do it for my sake, but for yours, Lale. God grant that I could give you the same boundless love."

A few days later she continued: "You know, you have let a ray of sunshine into my life, and I feel its warmth, and it is gradually helping me to see things more clearly. How good it feels to be like this, with open arms and an open heart—I'm begging for something to hold onto... If you were here right now, on this hill with the knotty pine and its golden brown trunk, I would lean my head against your shoulder and breathe calmly. Not to think, not to think so much! Lale, Lale, I think that I love you. Please be patient with me. You only get shreds, nothing very whole, but you certainly get something that's deep and sorrowful."

Finally, after almost two years, parts of which she spent in a sanitarium being treated for tuberculosis, Nunni began to feel that she could love him: "You are more and more frequently in my thoughts. Your heart is so big and warm, all I want is to just sneak in there and be very still. I'm so tired now but everything that's been hurting inside me has quieted down, and all that's left is something calm and deep."

It was never easy for my father to express his feelings in words. "I'm too happy and my heart is too full for me to be able to write a long letter," he answered. And then he added: "While I was preparing to go to sleep, I heard something odd. First I thought it was the leather chair, but then I noticed two dark spots in the ceiling above the window: water. Apparently, some

pipe had sprung a leak and the drops were falling on a heap of newspapers on the windowsill. Nice prospects for the night. So in order not to be kept awake by the dripping, I attached a small string with a thumb-tack at the very place the water drop was forming, and now it nicely runs down along the string and into a newspaper cone."

This practical, gentle, and intelligent man with a keen sense of humor was the perfect complement to my mother's sensitive nature and artistic temperament. Theirs was a life-long love story nowhere more in evidence than in the letters they wrote to each other during Finland's subsequent war years.

<div align="center">෴</div>

Nunni and Lale were married in the apartment in Helsinki where they would live for the first three years of their marriage, on November 3, 1928. Although Lale had graduated eight years earlier and his forestry career was going well, and Nunni likewise had her degree and was working, this was the eve of the great international depression, which hit Finland hard with inflation and unemployment. To save money, my mother made her own wedding dress, a simple short cream-colored smock with a tulle veil. In their wedding picture, they look serene and confident.

Soon after they were married, my mother hired Riikka, a diminutive and energetic thirty-seven-year-old woman, as an all-round domestic and cook. Riikka came from a poor Finnish-speaking family and had been forced to seek household employment when she was fourteen. She was fiercely protective of me and of my sister, who was born three years after my parents married. I grew up convinced that Riikka would always shield me from harm, even if my parents were not around. That was a good feeling to have in the fall of 1939, when the Soviet Union's unprovoked attack on Finland—only twenty-one years after the country had gained its independence—led to the first of three wars within a span of six years.

The first of these wars, the "Winter War," in the eyes of the Western world, constituted a small democratic nation's defense of freedom and justice. Winston Churchill called the Soviet invasion of 1939 "a despicable crime against a noble people." President Roosevelt spoke of Finland being "raped." Yet, the second war, the so-called "Continuation War" against the Soviet Union that followed in 1941, led to the dissipation of this vast goodwill. Finland, reasoning that the enemy of your enemy is my friend, hoped to counter the renewed Soviet threat by accepting the military help that Germany, for its own strategic reasons, offered. It was a terrible dilemma. My parents' letters offer an insight into what ordinary people thought about the situation at that time.

My own personal memories come mostly from the little-known third war that followed the armistice with the Soviet Union in 1944: the Lapland War, fought in the northern part of Finland against the Germans.

During much of this period, circumstances forced my parents to live apart. My father fought in the war; my mother dedicated herself to feeding us and keeping us safe. They wrote to each other constantly.

Reading these letters now, I marvel at the hopefulness my parents managed to maintain despite their darkest fears. Would my father make it home from the war? Would they ever see each other again? Would bombs destroy our home? Would there be enough to eat? Would Finland manage to stay independent, or would Russians or Germans occupy the country? Would we have to flee to neutral Sweden? And if my mother made it over to Sweden with us, would my father be able to follow, or would he end up in a prison camp in Siberia?

The Lapp King's Daughter

જ્જ

The Winter War

IN THE FALL of 1939, my father was forty-one years old and
had a good administrative job in a firm connected to the Finn-
ish forest industry. He had recently spent several weeks in the
Reserves receiving military training. My mother was thirty-five
and a teacher of physical education. They had moved from their
first home in central Helsinki and were renting a spacious apart-
ment on an island called Brändö (Kulosaari in Finnish), which
was connected to the city proper by a tramline crossing a rickety
wooden bridge. This idyllic, newly developed community, they
reasoned, would be an ideal place to raise a family. My sister was
six and about to start school, and I was two years old.

But the idyll did not last long. On October 5, 1939, the
government of Finland was asked, ominously, to send a delega-
tion to Moscow, in order to discuss "concrete political matters."
People's concerns over the future of the country grew with the
deepening autumn darkness. When our parents sat by the radio
to listen to the news, my sister and I knew we had to be quiet.

Joseph Stalin himself met the Finnish delegation at the
Moscow train station. He announced to them that "the border
of Leningrad is situated too close to Finland. Since we cannot
move the city, we have to move the border."

The Finnish government took a tough stand and refused the

demand for a border adjustment. True, the border lay within artillery range of the outskirts of Leningrad. But international opinion supported the position of the Finns: "It is hard to imagine that the Scandinavian states harbor plans that would stop Leningrad's inhabitants from sleeping soundly in their beds," wrote *The London Times* on November 15th. In the minds of most Finns, a concession to the Russians would have been the first step on a slippery slope toward the loss of independence, and historical documents have shown that an occupation of Finland was precisely what Stalin had in mind.

Three Finnish delegations shuttled back and forth to Moscow, their every move followed by an anxious people. The situation was deadlocked, and many Finns were beginning to feel that war was unavoidable. Others thought the Soviets were only bluffing. Nevertheless, the situation was tense. The army was mobilized and put on high alert. Field Marshal Carl Gustaf Mannerheim, a former Tsarist officer who had been Commander of the White forces during the Finnish Civil War of 1918, saw the conflict coming and pleaded, in vain, for a military buildup. In November 1939, the apprehensive Mannerheim was appointed Commander-in-Chief of Finland's seriously deficient armed forces.

<p style="text-align:center">∾</p>

My father expected to be called up any day. With war looking imminent, civilians were encouraged to leave the cities. On a dark October afternoon, my father, already in uniform, accompanied us—my mother, my sister Maj, Riikka, and me—to the Helsinki railroad station teeming with frightened people. He put us on an overcrowded train bound for his native Vaasa and Grandma Nanny. On board the train, I told anyone who cared to listen that my Papi had "gone to scare the Russians."

When my father got back to our apartment from the railroad station, he found his mobilization order tacked to our front

door. Two hours later, as our train was heading north, he was on a military train going east, with sealed orders. The country held its breath.

On November 13, 1939, Lale wrote to my mother: "Well, now Tanner and Paasikivi (the chief Finnish negotiators) have packed their bags and returned home. This was of course to be expected, since the demands of the Russians were so unreasonable. Now we'll just have to stay put here, since the Russians are practicing a war of nerves. No problem with nerves here—just let them try."

To my six-year-old sister, he wrote reassuringly: "Papi is well and commands one hundred and forty men and one hundred and twenty-eight horses."

Our train to Vaasa finally arrived, twelve hours delayed. "Wonderful to come to a warm home," my mother wrote from Grandma Nanny's. "Our beds were made up, there was tea and porridge waiting for us, and then we just stumbled into bed. Maybe you won't have time to read long letters, but I'm trying to write as legibly as I can so you can read fast. I just hope everything is well with you—please don't worry about us, we are fine. Maybe God will hear our prayers." Maj and I had now added a few extra words to our usual evening prayer: "God bless Papi and Mami and Finland and all the soldiers and let there please be no war."

But God did not hear our prayer. On November 26, 1939, the Soviet Union staged a classic border incident. Shots were fired, and the Russians claimed the shots had come from the Finnish positions and had hit Red Army personnel in the border village of Mainila. These shots actually turned out to have been fired by the Russians themselves. On November 30, the Red Army crossed the Finnish border as planes rained bombs over Helsinki and other cities. That same day, as Finns huddled in front of their radios, the Finnish President Kyösti Kallio declared the Republic of Finland to be at war.

"Oh, it's hard to explain things and to answer all the questions a child can put to you within the span of one day about all of this—those little hearts get more anxious than one would think. If I could only spare them some of the fear they feel," my mother wrote. "Everything is so horrible and meaningless, isn't there some way to stop all this? But don't worry, dear, you and I will get through this together, somehow."

എ

Other relatives had also sought safety in Vaasa. One of my mother's cousins, Aunt Ruth, was one of them. She was a petite beauty with a romantic and turbulent past. Her first husband, Yuri, a dashing Russian cavalry officer in the Tsarist army, had swept Ruth off her feet and she had followed him, unquestioningly, from Finland into a Russia swirling with revolutionary sentiment. In St. Petersburg, Ruth gave birth to a girl, Militza, who reportedly was baptized in champagne. Then came the revolution, and Yuri disappeared to fight the Bolshevik armies. Ruth, baby Militza, and their faithful Russian servant somehow made their way back to Finland. After some time, Ruth abandoned hope of ever seeing her husband again, and married a Finnish aristocrat and owner of a manor house in southern Finland. Soon after this, word came that Yuri had in fact survived and was in Finland, looking for Ruth and his daughter. Ruth was terrified: would she be accused of bigamy? The family closed ranks, and poor Yuri disappeared, never to be heard from again.

And now, Ruth was in Vaasa, with Militza and her two half sisters. My mother enjoyed her company. Ruth was wise and worldly, and had an irreverent sense of humor. She was also artistic, and Militza, to no one's surprise, grew up to be an artist. Ruth provided Nunni with a welcome counterweight to Nunni's sister Birgit's somewhat pedantic personality. "Oh Biggi, Biggi, and her circles," Nunni would say in exasperation

when her sister found it hard to roll with the punches. "She wants everything to be just so, and it just can't be."

<p style="text-align:center">〄</p>

Aunt Biggi, four years older than my mother, was very different from her sister. She was taller, and stiffer, both literally and figuratively. She had none of my mother's artistic talents or athletic abilities. But she was exceedingly kind and patient, and knew how to listen to children and take them seriously.

There was enough turbulence in Uncle Bert's early life to explain why he chose to marry a placid and steady woman like Aunt Biggi. Bert, a good-looking man with bushy eyebrows, half a head shorter than my aunt, was born in Estonia into a family of German extraction. Bert, or more properly Albert, was the youngest of thirteen children. In 1906, after his mother died, the family moved to St. Petersburg where Uncle Bert in 1916 applied to officer's school at one of the famous Tsarist regiments, the Pavlow Regiment. As a way of stressing the importance of proper table manners, he used to tell us stories about the application process for the Pavlow. To assure themselves of choosing officers who would be sophisticated men of the world, the selection committee invited the candidates to a series of dinners with the cream of St. Petersburg society. During these dinners, specially appointed ladies with eagle eyes would be seated next to the candidates and were asked to watch them carefully. Were they using the right fork, the right spoon? Were they holding the wine glass properly? Were they raising their glass to the correct height when toasting someone? Were they proposing toasts to the right people, in the prescribed order? Was the quality of their dinner table conversation worthy of an officer of the Tsar?

Uncle Bert was accepted, and became a Russian officer under the Tsar during the First World War at the worst possible time, just as the enlisted men in revolutionary fervor were beginning to revolt against their commanders. Once the Russian

Revolution had broken out, he managed to return to St. Petersburg and then tried to join a White regiment in Siberia. He got on a train going east, pretending to be a Siberian peasant. He faked his Russian accent successfully, but was nevertheless found out by Bolshevik soldiers patrolling the train because he had hidden a toothbrush in one of his boots—a toothbrush being a telltale sign of an educated man. He and two of his fellow officers were taken off the train and imprisoned in a cowshed in a small village. During the night, they managed to kill the guard and escape.

Uncle Bert returned to the chaos of St. Petersburg in 1918, trying desperately to hide his military past. He, like the rest of the city, was starving. He used to tell stories about living on "black market sausage" made of meat from dogs, cats, and rats. Finally, he fled to Finland and ended up in Helsinki, speaking neither Finnish nor Swedish.

One day he ran into a Finn he had met on a previous visit to Helsinki. This young man took pity on Bert and invited him home to meet his wealthy parents. Charmed by the cultivated but destitute stranger, they taught him some Swedish and found him a job as a correspondent in Russian and German in the export business where my aunt Biggi was working. An office romance led to their wedding in 1925, one year before my parents married. As Uncle Bert's Swedish improved—his Finnish always remained shaky and a source of mirth in the family circle—he did well in the business world and eventually became co-owner of a shipping company. Bert received his Finnish citizenship the year after he married, and remained a staunch Finnish patriot all his life, just as suspicious of Hitler as he was of Stalin.

❧

Even Vaasa turned out to be unsafe. After Russian planes had hit the city twice, Nunni decided we would move to the nearby countryside. She rented two rooms from a woman in the small

village of Petsmo, and that is where we spent most of the Winter War. The winter of 1939 was extraordinarily cold, and it was hard to come by wood to heat the small cottage. I remember thinking it was a natural thing for one's breath to show up as a white cloud indoors. There used to be hoarfrost on the heads of the nails on the walls when we woke up, and we would stay in bed under the covers until Nunni had gotten the fire going. We slept with our clothes on, in addition to which Nunni wrapped us in layers of newspaper when she tucked us into bed. The cowshed was by far the warmest place, and that is where we walked with our potty when we needed to, since the place had no indoor plumbing.

Nunni worried constantly about Lale. Was he keeping warm? Had he received the helmet cover that she had knit for him, the extra heavy socks? How about the knee-warmers? She kept skiing across the frozen countryside, and would hide in the forest when enemy planes flew overhead. "Do be careful when you see enemy planes," Lale wrote. "Don't ever show yourselves outside—there have been instances when they have shot at you even after they have passed."

"I long for you constantly, and I love you from the bottom of my heart."

I missed Lale, too. One day we encountered a family—a father, a mother, and their child—on one of our walks. The father, in uniform, was on leave. As we were passing them, I turned to my mother and announced: "I want my Papi, too." Many nights, as I lay in bed—and this Nunni was careful to note in her letters to Lale—I would knock on the wall next to my pillow. "This is Papi knocking. He is on his way." Any stranger would be informed that "Papi had gone away to scare the evil uncles." To me, he was a King. He had a uniform, and a thick leather belt, and round glasses that could see through anything. He would protect us from all dangers.

The freezing weather and the new snow turned nature around Petsmo into a winter postcard. "How does anybody feel

like fighting when nature is so beautiful?" my sister wondered as she was scanning the sky for enemy planes.

<center>✁</center>

The Winter War pitched David against Goliath. The Red Army of the Soviet Union fielded 450,000 men, two thousand cannons and grenade launchers, thousands of armored tanks, over one thousand airplanes and a strong fleet, against 275,000 poorly equipped Finns. The whole world was following this battle and expressions of sympathy for Finland's cause came from everywhere. "I am so incredibly happy that things have gone well so far," Nunni wrote to my father. "But shouldn't we soon get some different kind of help, not just expressions of sympathy—I do mean troops! Or airplanes!" The Finns were particularly bitter over the fact that the Swedes, anxious to preserve their neutrality, refused to send regular troops. They did assist Finland with generous humanitarian aid, with supplies and more than 8,000 voluntary troops, but their unwillingness to throw in their lot with the Finns left a lingering bitterness. The outcome of the war, however, most historians now believe, would probably have been the same since any Swedish aid could not have arrived in time to make a difference.

The Winter War was a three-month-long conflict fought in the bitter cold of the easternmost province of Finland, Karelia. The war helped wipe away the lingering traces of class hatred after the Civil War, and it united the Finns as never before. They fought fiercely, and the struggles of the Finnish soldiers on skis in white camouflage against an overwhelming Russian force created admiration and sympathy for Finland throughout the Western world.

<center>✁</center>

In his letter from a place he was not allowed to name, my father tried to sound reassuring: "The mood here is tops and the Ivanoffs [the Russians] have gotten what they deserve. I assume you

have followed the news on the radio. The quality of our troops is in all respects superior and well makes up for what we lack in numbers."

In the same letter, however, he added a carefully worded note: "On November 29, I received a letter from Erik Lindeberg in Sweden. He assures us that if you or any other of our relatives or friends deem it necessary to evacuate to Sweden, then he will do all he can to assist you or them. I don't for one moment believe that this will be necessary, but I want to give you his address just in case. God willing, you will never have to use it."

This was the first, but not the last time, my father would make contingency plans for us to seek refuge in Sweden. Lale worried about us: on a clear and cold Sunday morning in January, twenty-eight enemy planes had subjected Vaasa to a devastating bomb attack. And despite some initial successes and the bravery of the Finnish soldiers who would approach Russian tanks with Molotov cocktails, the war was plainly not going well for the Finns. Toward the end of February the Finnish military leaders, abandoning all hope of assistance from Sweden or from anyone else, realized that a Soviet break-through would eventually be inevitable. The Soviet military supremacy was simply overwhelming. They now had forty-five divisions, up from the initial twenty, or around six hundred thousand soldiers in the field. There was no choice for Finland: from a position of weakness, in March 1940, Finland sued for peace.

My sister's joyful shouts of "Peace! Peace!" are among my earliest memories. Nunni had taken the bus to Vaasa and was on her way home, but someone told my sister. She rushed out, got on her skis, and disappeared into the forest to meet Nunni at the bus stop. When they returned, Maj's mood had completely changed. Instead of meeting happy people, everyone she met had been somber. Some were crying. Nunni tried her best to explain to us that yes, there was indeed peace, but it was not a peace to rejoice over, for now.

The peace terms were indeed crushing. On March 13, 1940,

flags were flown at half-mast across the country. Many news-
papers framed the news of the peace terms in black borders.
In the streets, strangers greeted each other in silent grief, as the
Finnish troops on the eastern part of the Karelian Isthmus and
north of Lake Ladoga surrendered their positions. Along with
them marched the 400,000 Karelians of the newly ceded areas.
"The exodus of the Karelians, a civilian Dunkirk, was a human
tragedy as vast as had been the war itself," wrote the Finnish
diplomat Max Jacobson. "By a stroke of Molotov's pen, every
eighth inhabitant of Finland had been deprived of home and
livelihood." Miraculously, even under the harsh post-war condi-
tions, the Finns managed to absorb these refugees from Karelia
into the rest of the population without having to put them in
refugee camps.

This was a tragic defeat for Finland: 26,600 men died, and
over 550,000 were wounded. Over one thousand Finnish civil-
ians were killed. The Hanko Peninsula west of Helsinki was
leased to the Soviets for thirty years to be used as a naval base.
The bitterest pill of all was the loss of the whole Karelian Isth-
mus, the area between the Gulf of Finland and Lake Ladoga—
one tenth of Finnish territory, as well as the country's second
largest city, Viipuri. The Soviets, however, lost five times as many
men as the Finns. At the time, that was no consolation, but the
stiff resistance of the Finns created a respect for the country even
among the Russians themselves. "The Finns fought like heroes,"
was the grudging praise of Soviet Marshal Timoshenko after the
Winter War.

Where would help come from, the Finns asked themselves,
if Stalin decided to try again and war would break out anew? As
we left Grandma Nanny in Vaasa and took the train back south
to Helsinki, that question would loom over the country like a
dark cloud.

Stalin or Hitler?

T HE PEACE that followed the Winter War did not feel like peace. Schools did start up again in Helsinki, but nothing seemed normal. People were storing extra food; adults were having anxious conversations. My parents, greatly relieved to be reunited again, listened to every radio newscast. A political war of nerves was to last for fifteen months.

Yes, the Finnish military had shown the world that they could keep the Russians at bay. But after the Winter War, Finns were less inclined than ever to trust Stalin. He would try again, and this time, he might succeed, unless there was help. Where would that help come from? It was plain to the Finns that no Western power would come to their aid in a future conflict with Russia.

In Berlin, Hitler had followed the Winter War with great interest. He drew a fateful conclusion: the Red Army was weaker than he thought. It had failed to overrun Finland. Maybe an attack on the Soviet Union would be feasible, especially if part of it could be launched from Finnish territory? Hitler's desire to stage his attack on Russia—Operation Barbarossa—and the Finns' need for protection—reached a stage where some kind of military alliance began to look good to both sides.

This was a terrible moment for Finland. No one, except for a

small lunatic fringe, had any sympathies for Hitler. I remember Uncle Bert shaking his head at Hitler's raving exhortations on the radio, and my father nodding in assent.

They had closely followed Hitler's expansionist policies. Even before the Winter War, in 1936, he had occupied the Rhineland—in clear violation of the Treaty of Versailles, which declared the area a demilitarized zone. In 1938 Hitler annexed Austria, where Adolf Eichmann in eighteen months reduced the Jewish population by half. In March of 1939, Hitler occupied Czechoslovakia. Both Britain and France, though desperate to avoid war with Germany, could no longer ignore his intentions, and, when Nazi troops marched into Poland on September 1, they demanded immediate withdrawal from Polish soil. Hitler refused, and Britain and France, followed by Canada, Australia, and New Zealand, declared war on Germany. World War II had begun.

On the European continent Hitler was steamrolling west. Thanks to his disingenuous non-aggression pact with Stalin— the Molotov-Ribbentrop Pact—he did not have to worry about his eastern front. According to a cynical secret addition to the pact, suspected early by the Finns and finally admitted to by the Soviet Union in 1989, Stalin would have free hands to occupy Latvia, Lithuania, Estonia, and the eastern part of Poland, as well as Finland in the north. One after the other, delegations from the hapless Baltic countries were called to Moscow and served with ultimatums and threats of invasion. And one after the other, starting in June 1940, the formidable Red Army occupied the Baltic countries. After staged elections, new puppet governments were established and greeted by "spontaneous joyful demonstrations." The moment was well chosen: the attention of the world in June of 1940 was on France and the fall of Paris.

The Soviet secret police lost no time instituting a reign of terror in the Baltic countries. They arrested "anti-Soviet elements"; they staged mass deportations. Thousands disappeared

never to be heard from again. In July 1941, however, the German Wehrmacht drove the Russians out of the Baltics and remained there until the country was re-taken by the Soviets in 1944.

Needless to say, Finns followed these events with horror and a deep sense of foreboding.

છ

In June 1940, as France fell to the Nazis, Hitler began to finalize his plans for his Operation Barbarossa invasion of the Soviet Union. Back in Moscow, Stalin was handed intelligence information that referred to the coming Nazi attack, but he either refused to believe it or failed to react from fear of provoking Hitler.

Hitler made his first overture to Finland by offering the Finns a deal: they could buy German arms, as long as they allowed German troops to pass through northern Finland on their way to and from occupied Norway. At the time, this looked to the Finnish leaders like a welcome counterweight to Soviet pressure. But, in reality, the transit agreement irrevocably put Finland in the German camp. As Max Jacobson wrote, "It was the first step in a systematic German campaign to tie Finland to Hitler's war plans." The German troops would not only move through Finnish territory back to Norway, but through Finnish territory to attack the Soviet Union.

To the majority of Finns, Nazi Germany in 1940 was the lesser of two evils. If hostilities broke out, Finns would insist they were not strictly speaking allied with Germany. They would be co-belligerents. Maybe this was a point lost to the wider world. The U.S. government, however, never declared war on Finland, recognizing that the Finnish-Soviet conflict was separate from German war aims. There was no sympathy for Nazi ideology in Finland. It was simply a question of how best to guarantee national survival.

The first German vessel carrying troops arrived in the harbor

of Vaasa in September, 1940. In May and June of 1941 there were already more than 100,000 German troops under General Eduard Dietl in Finnish Lapland. It was no longer possible for the Finns to pretend that they were neutral: the country had chosen sides.

There was widespread popular support for this position. The country's independence, people felt, was at stake. After the Winter War, the Soviets had already meddled in Finland's internal politics on many occasions, most notably by declaring their opposition to certain presidential candidates in the election of 1940. It was feared worse was to come.

There was another reason to reach out for German military support. A renewal of hostilities, this time with German support, would give Finns a chance to regain the territory that had been taken from them in the Winter War. People began to refer to this time as the "interim peace," a term with overtones of revenge that did not go unnoticed in Moscow.

On June 22, 1941, Germany put Operation Barbarossa into action and attacked the Soviet Union. "Hitler," the statement said, "proclaims that he, in order to defend Europe, has formed a front that stretches from the Arctic Sea to the Black Sea and that he has given his troops orders to act." Anxious to avoid the appearance of having joined Operation Barbarossa against the Soviets, Finland didn't immediately attack, although military co-operation with Germany had been agreed on in principle. From the Soviet standpoint, the German troops in the north were a clear provocation, and the Finns knew it. The country mobilized, and the government issued a communiqué: "We find ourselves in immediate danger. The free and independent Finland expects each citizen, at this serious juncture, to do his duty and, exercising self-control, calmly continue his work in the strong belief in a happy future for our country."

သာ

Once again, my mother packed our suitcases and we headed for the Helsinki railroad station and Vaasa. This time, the station teemed with refugees in the near constant daylight of mid-June. My father had already left for the east, on yet another military train. Once again, the country waited, the tension mounting. But this time, it was better prepared. And this time, there was help.

From Grandma Nanny's in Vaasa, my sister wrote an excited letter to her best friend Hecko: "You know, it's pretty great here, because there are all these Germans! There are so many of them that they fill practically the whole city. You have no idea how many Germans there are! They all waved at me when I sat on the back of Mom's bike. Then I could hear a song! And then we saw the Germans marching, and singing. There was such a long line of them that you have no idea. And they have huge horses! And the Germans gave chocolate to the children! And you have no idea how much food we have here, sausages, whatever you like! This morning, half of the workers of the factory where Grandma Nanny works were called up. They all drank their goodbye shots of vodka. So today, you only saw drunken people. But Hecko, don't you think it's terrible if there is going to be a war again? If that happens, I'm going to be so MAD."

Just as she had done in 1939, Grandma Nanny did her best to make us feel at home, and Nunni tried hard to make our presence less of a burden to her. "Grandma is happy to have us here," Nunni wrote to Lale. "She is resting more now that she doesn't need to cook and clean."

છ૩

Grandma Nanny was, despite her mild manners, a fierce patriot. She retained vivid memories of the Russian repression under the Tsars. One of her heroes was the young nobleman Eugen Schauman, who in June 1904 assassinated Nikolay Bobrikov, the hated representative of Tsar Nicholas II to the Grand Duchy of

Finland, by pumping three bullets into his chest before shooting himself. News of the assassination produced much exultation among the Finns. One of the many Finns hauled into jail following Bobrikov's death, on the charge of "unmotivated happiness," was rumored to have been the composer Jean Sibelius. All this Grandma Nanny would talk about, her red cheeks glowing. And then she would whisper: "When your uncle Totti was born in August that same year, we wanted to name him Eugen, after the man who shot Bobrikov. But we didn't dare."

Grandma Nanny used to evaluate the Tsars. "That poor man," she would say of the last Tsar Nicholas II, "was such a weakling. He didn't know what he wanted, and he paid for it with his life." For Nicholas's father, Alexander III, she had nothing but contempt. "He was a boorish man. No refinement." Her favorite Tsar was Alexander II, the father of Alexander III. She told me how good he had been to the people of Russia. He had freed the serfs and was about to grant the Russians their first constitution. "And just hours before that, a terrorist threw a bomb at his carriage. When he stepped out of his carriage to check on his guards who had been killed, another terrorist threw a bomb at him. He was blown to pieces."

Tsar Alexander II had been good to Finland, Grandma Nanny used to say. He let us have our freedoms. And so we put up his statue on the Senate Square in central Helsinki, just steps away from the place where Eugen Schauman had shot Bobrikov.

<center>❧</center>

The story I remember best was one I was not intended to hear. It was late afternoon, and I was playing quietly with my little wooden horse and buggy in the corner of the living room as Grandma Nanny and Nunni were having tea.

"You know, these German soldiers," she said to my mother. "They remind me of the time Russian troops were all over town, before Independence, and what happened to my friend

Adelaide. Can you imagine, once she was walking down the Esplanade, it was winter and cold and she was all bundled up in her fur coat and hat. You could only see her big, dark eyes. But that was enough. Down the Esplanade, straight toward her, came this Russian officer. Apparently he was extremely handsome. They both slowed down, their eyes locked. They just stared at each other, and before she knew it, he took her arm and—not even introducing himself to her—they walked into the hotel right there and got a room, for the whole afternoon. She told me there was nothing she could have done, and that it was wonderful."

As Grandma Nanny poured some more tea, I was dying to ask what it was that had been so wonderful. Something in their voices told me I'd better not ask, but I decided from then on to keep an eye on my eleven-year-old sister and all those German soldiers.

<center>୧୬</center>

On June 25, 1941, the expected Soviet response to Nazi Germany's aggression came in the form of massive Russian bombing raids on military targets in Finnish cities, from Rovaniemi in the north to Turku in the south. The next day, we huddled around Grandma Nanny's radio in its tall brown wooden case as President Risto Ryti, in a somber address to the Finnish people, declared the country once again at war. On June 30, Finland joined the attack on the Soviet Union, and, once again, it became clear to Nunni that even Vaasa would no longer be safe.

Late one afternoon, as smoke rose from the ruins of burning buildings, we said goodbye to Grandma Nanny, gathered our few possessions, and clambered onto an open truck and headed for the relative safety of Malax, a small community south of the town, where my mother had a friend who took us in.

The summer in Malax was a hot one, and we made frequent trips to a beach and to outlying islands. "This is the fifth week in

a row that Stina has not been wearing any clothes," Nunni wrote to Lale. "Just a nightgown at night. Wonderful to see those small bodies naked the whole God-given day. They are both as tanned as gingerbread. And here I sit by the shore, the warm and still water at my feet, the mosquitoes playing their violins high up in the sky, everything is summer evening, and I am your very own girl."

Maj wrote: "Dear Dad, how is everything there? I'm very homesick, so homesick my pants are bursting! There are usually charming sunsets here. Today we had a fish soup that Marianne and I had fished—huge perches! Ten million kisses to you from Maj and Stina."

<p style="text-align:center">℘</p>

That summer, Riikka considered leaving us. Both she and my mother being quite stubborn, had had their differences, but that was not the reason. Late in her life—by this time, she was in her mid-forties —Riikka had a suitor. The rotund and jovial parish organist in Malax, who was "kindly, helpful and a little bit simple upstairs," according to Nunni, had proposed to her.

I was aware of some teasing and smiles and glances in Riikka's direction as she went for her evening walks. There was a man who was her friend. But it never occurred to me that Riikka might not always be part of our family. She was always there. And she always would be, cooking, doing the washing, taking me for walks, and playing with me.

Not until I had my own children and Riikka was in an old age home in Helsinki did I ask her about that summer and her "friend." What had kept her from leaving us and marrying the parish organist? Had she not liked him enough?

She looked at me and smiled. "You were still very young," she said.

<p style="text-align:center">℘</p>

If Molotov and Stalin were the evil figures of my wartime child-hood, then Baron Carl Gustaf Mannerheim was the knight in shining armor. Born into an aristocratic family and raised in Finland, he joined the Imperial Russian Army where he advanced to the rank of Lieutenant General and commander of an elite cavalry corps in St. Petersburg. At the coronation of Tsar Nicholas II, Mannerheim was one of two honor guards especially chosen for their stature and elegant looks. In 1917, he returned to Finland to become the victorious Commander-in-Chief of the White forces, under whose banner my father had fought, in the Finnish Civil War of 1918. To my parents, he was a hero. To the "Reds" on the other hand, he was the "butcher general" ultimately responsible for atrocities committed against them and for deplorable conditions in the prison camps during that bitter conflict. The Winter War, with Field Marshal Mannerheim as Commander-in-Chief, did much to unite a divided people against a common enemy, and now, on the eve of the Continuation War in June of 1941, he assumed this role once again.

Mannerheim was much more than a military man. In hindsight, it is hard to see how the country could have escaped occupation by the Soviet Union without his guiding hand. Speaking flawless Russian, Mannerheim knew that country's soldiers and had a deep respect for their fighting capacity. He also understood the mentality of Soviet politicians and was aware of the importance of treating them respectfully during negotiations and, if possible, negotiating from a position of strength. He was no admirer of the Nazis and wanted no part in a German occupation of Leningrad. He reined in those Finnish politicians who in their partnership with Germany saw a chance to extend Finland's borders beyond what they had been before the Winter War. The opinions of this charismatic man carried extraordinary weight in Finland. At the start of the Continuation War, Finland no longer commanded the world's attention as a brave little

nation fighting an evil empire. In the eyes of the West, the country had joined the wrong side. But the personality and authority of Mannerheim went a long way toward supporting the view that Finland had been placed between a rock and a hard place and that it had chosen the only alternative for national survival.

<center>⁓</center>

One of the ways in which the Finnish leadership showed its independence vis-à-vis the Germans was in relation to the Jewish question. Here was Finland, co-belligerent of a country determined to wipe European Jewry off the map. There was a relatively recent Jewish community in Finland, not exceeding two thousand people, most of whom had come there as merchant traders or with the Russian military. Some of them were now drafted into the Finnish army and finding themselves fighting alongside the Germans! The Finns repeatedly stressed that, as far as they were concerned, the Finnish Jews were no different from everyone else and that their patriotism should not be questioned. Field Marshal Mannerheim underscored this point by paying a visit to the Synagogue in Helsinki at the end of the war.

Anti-Semitism in the military was not an issue. There was even a field synagogue, tolerated by the Germans. The Jewish soldiers fought well for Finland, but would not go as far as accepting German military decorations for their bravery.

There was, however, an unfortunate incident when eight Jewish refugees were deported to Estonia and handed over to the Nazis. This deportation led to an uproar in Finland and may have contributed to the fact that the Nazis never pressed the Finns too hard to hand over their Jews. The Germans needed the Finns as military partners more than they needed their Jews. Finland did, however, hand over prisoners of war to Germany, and there might have been some Jewish prisoners among those. But the official stance was clear: at one point, according to the then Prime Minister Rangell, Himmler had brought up the

question. Rangell's reply had been that the Jews were decent people and that there was no Jewish question in Finland, and the matter was left at that.

<div align="center">❧</div>

The overarching question for us that summer in the countryside south of Vaasa was very simple: would there be time to gather and conserve enough food—berries, mushrooms, vegetables— to last us through the following winter? Exhorted by Lale in his letters, Nunni and Maj went on long trips to pick berries. As a food gatherer, I was still useless. Instead, I spent a lot of time that summer trying to figure out how I could teach myself to fly. It should be possible, I thought, to lift oneself up by one's pants, as one jumped from a few steps up the staircase. And it might come in very handy, if the Russians approached.

CHAPTER THREE

Russian Weather

A T THE END of my fifth year of life, I knew two things for
certain: as long as I could see Nunni at her desk writing a
letter, my Papi was alive. He was gone to something called The
Front, to scare the Russians away. Nunni wouldn't be writing to
him if he had died.

And something else was certain too: tonight, the Russian
planes would appear, because all day, we had had Russian weath-
er. The sun was shining from a clear blue sky this cold winter
day in 1942, and that was not a good sign. You could tell the
grownups were worried: they kept looking up at the sky, and I
was allowed out to play in the snow briefly, but only if I wore my
white snow cape so the Russians couldn't spot me. As I prepared
for bed, I made sure my stuffed dog was securely next to me, so
I could take him along if we needed to rush down to the air-raid
shelter.

Just after midnight, "Hoarse Freddy," the mushroom-like
siren on top of our apartment building, started his warning wail.
Nunni hurried in to wake me, and on came my itchy long stock-
ings, the padded coat, the felt boots. I knew there were three
hundred and twenty steps of spiral staircase down to the com-
munal laundry room in the basement that served as our shelter.
The door was creaking as family after family made their way

in. The air had a musty, stuffy smell as we navigated our way to the back wall through a forest of wooden pillars placed there to prevent the roof from caving in on us in case of a hit.

From time to time, as someone opened the door, we could hear the droning of the planes and the rat-tat-tat of the air defenses. Searchlights swept the black sky. There was an explosion, and then another one, closer. I looked at Nunni: how close was that? She smiled at me, and I knew: Molotov and Stalin would not find us here, and Papi was out there somewhere to scare them off.

The next day was overcast and Nunni took me along when she went downtown. There was very little traffic; all available gas went to the military. The few cars we saw were sputtering along fitted with wood-gas generators that looked like big barrels. To me, that was simply the way cars looked.

We rounded a corner. Right in front of us was an apartment building with its front blown off in last night's bombing. In the street, people were slowly poking through the rubble. It looked like a giant doll's house. On the third floor, I could see a bed, and next to it a chair draped with clothes. A painting of birches reflected in a lake hung askew on a wallpapered wall. I could tell that Nunni wanted to turn around, but it was too late.

"Is this what will happen if a bomb hits our building?"

Nunni smiled at me. "No, never. Our building is much stronger."

"And where did the people go?"

"To the countryside, I'm sure."

The next day, Russian weather returned.

⁓

"My dearest boy," Nunni wrote to my father on November 22, 1942. "How are you this Sunday afternoon? I've just had some afternoon 'surra' [a coffee substitute based on dried dandelion roots] and the radio is playing softly. I've rested a couple of hours,

because my head is a bit heavy after all that went on last night. The first alarm came around ten o'clock, and lasted about two hours. The next, at 2:20 in the morning, and the third around three o'clock in the morning, two of them with heavy air defense shooting and bombs. And this afternoon, we've already had two alarms, so it's been five in all this day so far. Who knows what else will happen if there is moonlight. It's reasonably warm in the shelter, but it's hard on the backside to sit for so long. One can only be grateful that we've been spared. The children are sweet and take everything calmly—don't worry about us, we go down to the shelter right away—there is nothing more we can do."

That night was followed by another five-alarm night, starting at eleven o'clock and ending at six in the morning. This was a source of some satisfaction for my eleven-year-old sister Maj, since there would be no school the next day if we stayed in the shelter beyond midnight. My mother decided we would spend the next night sleeping in the shelter right from the start, as did many other families. At this point, Lale's sister, Majsi, whose husband was at the front lines, and my two cousins, Barbro and Gretel, had also moved in with us. Grandma Nanny was living with us, too. Nunni had to worry about feeding all of us. "But don't worry, dear," Nunni wrote to my father. "We'll be fine. I'll just add a little bit of extra love to this soup."

A few days later, Nunni wrote: "Dear, it's been rather unpleasant. Last night we had three alarms; twenty-four alarms this month so far. I dearly hope tonight will be overcast. The children are tired and for the second night in a row, I slept with all my clothes on, shoes and all and a baby blanket inside my pants, the shelter wall where I sit is so cold. You get down there with a certain dispatch, it doesn't take many minutes before they start thundering. Sometimes we don't even make it into the stairway. And then we get hungry: I try to take along some sandwiches and a thermos of substitute coffee. For a couple of nights now, I've tried to stay down there with Stina, but she can't get to sleep if she's not in her own bed.

"Dear, congratulations on your promotion to the rank of Captain. Stina asked, on what ship? I was going to say, on the steamer *Finlandia,* but didn't want to confuse her little head."

&

I knew that there had been a time when there was no war. I knew that when Papi and all the other brave soldiers were done scaring the Russians, the war would stop. From what I could understand, the war was the fault of two people whose names were constantly repeated over the radio: Molotov and Stalin. I drew a picture to illustrate the situation, as I saw it.

A man with a flowing beard and wings stands on a cloud, with outstretched arms. You can see into his belly: it's divided into a black and a white field. Deep at the bottom of the black field crouch two stick figures.

"This is a picture of God's tummy," I explained to Nunni. "The black part is Hell. And those two down there are Molotov and Stalin."

In the next picture, God reappears. This time too, you can see into his belly. It is filled with small white circles.

"This is God, and he has wiped the tears off the eyes of all the people. The tears are now in God's tummy, around his heart."

Nunni dated and saved the pictures.

&

Nunni and Lale hid it well from us, but the early part of 1942 marked the beginning of exceptionally hard times for Finland. Food supplies were running dangerously low. Imports of food from abroad had come to a standstill. What you could get for the food ration coupons was rarely enough to feed a family; everyone had to supplement those rations as best they could. Fully one third of provisions came via the black market. If you knew people in the countryside, you were lucky: you might be able to buy some eggs, or a liter of milk, or even some meat. Acquiring these things was not without risk, however: the dreaded

Ministry of Supply, with its huge bureaucracy of 5,000 employees, had their spies on trains and on buses coming and going between the cities and the countryside. Any bulging bag was likely to be searched for forbidden foodstuffs. As money lost more and more of its value, bartering flourished. The country was back in the "Squirrel Fur Age." Every day, newspapers were full of ads: "Have a pair of shoes, size 42. Would like to exchange for flour." "Have five packs of cigarettes, Westminster, would like to exchange for real coffee." "Have a child's bathtub, would like to exchange for eggs or butter." "Will buy rabbit, squirrel, or cat furs, highest price offered." There was hardly any meat; people in the cities took to keeping pigs and sheep in cellars and raising rabbits in their bathtubs. Food, and the lack of it, continued to be the primary subject in my parent's correspondence.

"Yes, dear," wrote my mother, "I did get both your letters as well as the fifth keg of frozen reindeer blood, it took some effort to get it home, but it's good to have it. A nice truck driver hauled it to the tram from the railroad station, the conductor helped me lift it up, and down again at our stop, and then I rolled it all the way down to our front door. It left bloody traces in the snow, and it looks bloody and dangerous and it weighed over 40 kilos—please don't send any more before asking me!! I've kept some and given some away. Today, the moose meat arrived; we'll taste some of it in a few days—I marinated a piece of it in vinegar and cloves. I'm going to do some baking for Christmas—I'd rather sleep over the whole thing, but will have to try, for the sake of the children."

Packages arrived from my father whenever he could get something: more grouse, feathers and all, that Riikka plucked over the kitchen sink and then singed over the open fire of our wood-burning stove until our whole kitchen smelled like burnt hair. He also sent a shipment of salted fish, and more moose meat. No more kegs of reindeer blood showed up, however—we had had enough of blood pancakes and blood bread and blood puddings despite all that good protein.

The oatmeal porridge we ate was full of chaff, and the army cracker bread that civilians sometimes could get had small worms that we needed to brush off before putting it in our mouths. That bread had a smooth side while the other side was full of small indentations. We were admonished to always "butter" the smooth side: that would use less of this mixture of yellow-colored lard and other fats that passed for butter. We would stand in line after line, not even knowing if there was anything at the end of it. Often, there was nothing.

Lale's letters chronicled his constant food searches: "Tomorrow, or the day after, I'm sending you a special delivery box containing moose meat, about 30–40 kilos! Yes, the box is a bit heavy, but if you and Riikka pull it home on the sled together, you should be able to manage." My mother answers: "The box arrived—how wonderful to have it! My dear, how on earth did you manage? Now the food problem is solved. I don't have to wake up anymore, as I did the other night, with real tears in my eyes, sobbing. I was going to buy some fish and the fishmonger just took his cart and walked off, right in front of my eyes...."

The winter of 1942 was uncommonly cold. Our apartment was freezing. To make her trips into town on the unheated tram more comfortable, my creative mother exchanged some butter for a black sheepskin that she sewed onto the inside of her thinning winter coat.

Finally, spring came with its milder weather and longer days. When young nettles began to sprout, we picked them by the basketful for "spinach" and soup. We gathered dandelion roots and dried them for substitute coffee. We dried raspberry leaves, flowers from the linden trees, and black currant leaves for "tea." And as spring turned into summer we, along with our neighbors, tended our small garden plots of carrots and potatoes, peas and radishes, beets and beans, utilizing every square inch. There was intense cultivation of vegetables and potatoes going on everywhere: even in the city, some open squares and market places were converted into potato patches.

One day, I found my mother at her desk, looking intently at a small pile of gold jewelry. There was my grandmother's watch that she used to wear around her neck on a gold chain. There was a brooch with gold and pearls, and a hatpin with diamonds. Nunni looked at me as she took her wedding band off her finger. "These are going to the military, so that they can buy more airplanes to defend our country," she said, her voice unsteady. In exchange, she told me, she and all the other women who relinquished their wedding rings would receive plain iron ones from the government. Nunni wore hers, like a badge of honor, all her life.

Watching her do this, my heart sank. This too was the fault of the Russians. So why, I asked Nunni one day, had God created those Russians in the first place? Since they didn't do any good?

∽

Right around this time, a wonderful new thing arrived in our apartment. It was black and shiny and sat on the desk, smiling invitingly with the letters of the alphabet framed in silvery circles. Hit one of them, and a key would fly up and make a letter on the paper curled around its black roller. Come to the end of the line, and a gentle "ping" would tell you to shift to the next line. My mother used the Underwood for her work on the women's physical education magazine she edited. It would never have occurred to her to use the typewriter to write to my father. The Underwood was mine for long stretches of time, and my mother saved every scrap of paper I wrote on it. I could only produce capital letters, and didn't know about the space bar. Looking at these papers now, the cryptic clusters of capitals look like messages from an ancient civilization: WECANTBUYMEDISINS. THERUSIANSAREBAD. KLOSEBOMBLASTNITE. WEGETPOTATOS. And finally, IAMNOTAFRAD.

∽

There was one way our parents could have spared us from the perils of wartime: they could have sent us to Sweden. Had my parents asked me to go, I might well have agreed. Sweden sounded good to me. I had met some Swedes, friends of my parents, and the women smelled of perfume and had fancy clothes, although they spoke a funny, sing-song kind of Swedish. I had seen pictures of the Swedish royal family in magazines. A King, a Queen, Princesses! And I had heard stories: there was no war there. There was Peace. You could have as much chocolate as you liked, and oranges. You could buy new shoes by just walking into a store. Two of my cousins had been sent there, and several of my friends.

In my mental geography, Sweden existed on a higher plane. Finland lurked low down, in half-darkness. To get to Sweden from there, you would walk up a long, wide flight of stairs. Music would be playing as you opened the doors to Sweden, warm and bathing in sunlight. Sweden was Paradise.

But my parents never asked if I wanted to go.

<center>∾</center>

Some seventy thousand Finnish children, however, in one of the largest child transports in history, did go. It was an exodus on the model of the Kindertransports that sent mostly Jewish children to England, away from the Nazis in Germany, Austria, Poland, and Czechoslovakia in 1938 until the outbreak of the war in 1939. Most of the Finnish children were sent to Sweden, four thousand to Denmark and a hundred to Norway. Perhaps their fathers had fallen in the war. Perhaps there were too many other siblings to take care of. And so trains filled with babies, toddlers, and children up to twelve years old, with big name tags around their necks and clutching small bags with a few belongings or a favorite doll, chugged through the frozen countryside with their volunteer caretakers to Tornio in the north, where they would cross the border to Sweden. Sometimes, Russian

bombers strafed the trains, or they would be delayed for hours to let military trains pass. Other child transports left harbors in the west to cross the wintry sea, until that became too dangerous. Thousands of homes on the other side of the border opened their doors and their hearts to these children. But for many of them, this love came in a new language while the old one faded from memory, along with all the hardships they had left behind. As the years and months passed, they grew accustomed to their new lives, and many of them began to forget their parents. Then the war ended, and they were faced with another wrenching departure from a family and new "siblings" they had learned to love. Back they would go, to a country devastated by war and with scarcities of every kind, to be met by parents whom they barely remembered and whose language they had almost forgotten. The child transports had been put in motion out of the purest of motives, but they left deep and permanent scars in a whole generation of children, who would wait almost a lifetime before they could talk about their experiences. Some ten thousand children never returned at all.

<p style="text-align:center">☙</p>

How close did my parents come to sending my sister and me to Sweden that winter of 1942? Would they have done so if they had known that we still had three years of war ahead of us, and that the outcome would remain uncertain until the very end?

In their letters, my parents sound like they are always hoping for the best. But hope was hard to come by in the winter of 1942. As the tide of war was beginning to turn against Germany, it became clear to increasing numbers of Finns that they would eventually have to seek a separate peace with Moscow. How that kind of diplomatic dance would be accomplished without incurring the wrath of the Germans, nobody knew.

An Unusually Obstinate People

"THEY ARE an unusually obstinate people," an exasperated Joseph Stalin once complained to the U.S Ambassador in Moscow, Averell Harriman. He was talking about the Finns. "Common sense has to be beaten into their heads with a sledge-hammer."

Initially, the Continuation War went well for the Finns. The Finnish army advanced into and beyond the territories that had been taken from them in the Winter War. At the end of August 1941, Viborg was back in Finnish hands. On October 1, the Finns took Petrozavodsk on the shore of Lake Onega, deep in Karelia, and renamed it Äänislinna. By the end of 1941, the Finns advanced far into eastern Karelia, beyond the former border with the Soviet Union. Heady and dangerous talk about a future "Greater Finland" was circulating.

My father had been stationed on the Hanko Peninsula a mere hundred kilometers west of Helsinki, the tip of which had become a Russian military base at the end of the Winter War. In December 1941, the Russians could no longer hold on to it. There was euphoria among the Finns. Karelia in Finnish hands! Viipuri and Hanko back! Thousands of Karelian refugees from the Winter War started return journeys back to their abandoned homes, some of which were in ruins. Most of them were wom-

en and elderly people, since the men had been drafted. By the end of 1941, about 75,000 civilians had made the trek back to their beloved land. In the spring of 1942, another 90,000 more came back. The stream of returning refugees held steady until 1943, when about sixty percent of the refugee population had returned. They had no way of knowing that their joy would be short-lived.

"Amazing, the way things have progressed!" exulted my father from the Hanko Peninsula. "Good news each and every day! Today, I visited Julius [von Julin] and we celebrated the liberation of Viborg with coffee and orange liqueur."

My mother wondered: "All of this is good news, but there are so few details from our own country. Hard to know what to think: but certainly the German reports are music to one's ears, really phenomenal accomplishments." News from the front was heavily censored; private letters were frequently opened. My father confessed, on a more skeptical note: "I don't think this will be over very soon, let's see if we won't have to celebrate Christmas in uniform. Of course, it's going well, but perhaps slower than many would believe."

In fact, some people, despite the efficient propaganda, were already beginning to have their doubts about the German military might. Were they really going to take Leningrad in just a few weeks? And then march on to Moscow, which would surrender in no time? The Leningraders were putting up a heroic resistance to the German siege of the city—a civilian tragedy of vast proportions that would last for 900 days and end only after one third of Leningrad's population had died of starvation. The Germans would never take the city. Part of this was due to Marshal Mannerheim, who, despite German exhortations, refused to take part in the advance on Leningrad, where a Nazi victory in a crucial area would have cut off the city's last link to the outside world. Thinking far into the future, he realized how, in case of an Allied victory, a Finnish participation in an attack

on Leningrad would undermine the Finns' claims that they were fighting a separate war against the Soviet Union. There was no way he would let the country run that risk.

By the end of the year, it became clear that the German attack on Russia had bogged down. The German soldiers had been sent on this mission in their summer uniforms, something the Finns found hard to believe. In Hitler's mind, the war would be over before winter set in—and now the troops were freezing to death.

Following these developments closely at the Finnish Military Headquarters in the central Finnish town of Mikkeli, Mannerheim began to think ahead to the day when Finland might have to disengage herself from association with the Germans. This became even more important after December 1941, when the Japanese bombed Pearl Harbor and the United States was drawn into the war. A conflict with the U.S. would have to be avoided at all cost. Mannerheim put the brakes on all offensive operations on the eastern front. The Finnish army would stay in its positions, despite repeated German entreaties to be more aggressive.

ↀ

After the Soviets withdrew from Hanko, my father received a new posting: he was sent all the way east to Äänislinna. Most of the letters he wrote to my mother during the rest of the war were postmarked from this Karelian outpost—today's Petrozavodsk—on Lake Onega. But before he got there, he was posted for six months in the eastern town of Joensuu, near the paper mill where Nunni was born. We were still in Vaasa, where Grandma Nanny entertained me with stories about the tragic sinking of the *Titanic* and how the band had disappeared into the freezing waters playing "Nearer My God to Thee," which left me puzzled about the exact point at which the band had actually stopped playing. Was it when the violins hit the water? When the piano

case had filled up with parts of the iceberg? When the conductor no longer was able to conduct? As a change of pace, she would whisper to me about the heroes of the Bhagavad-Gita, the noble Prince Arjuna and the armies of the Kauravas and the Pandavas, as if they were encamped just outside our windows at the Vaasa marketplace, waiting for the battle to begin.

In early October 1941 Nunni wrote to Lale, who was on leave in Helsinki: "Just heard the news about the Helsinki bombings over the Swedish radio. What to do? We are longing to come home, but what would be best? The things I sent should be unpacked and taken to the cellar. The keg of butter needs some salt on it and water, so it doesn't spoil, put it on the top shelf where it can't be seen. Tomorrow Mrs. L. will come here from the countryside, with more butter, flour, eggs, and potatoes. I have found 7 kilos of onions for 22 marks. The lines for lingonberries in the marketplace are long and people are wild, but I'll try my best."

Back in Joensuu, Lale replied: "My dear girl, greetings from a cold and wintry town with a full moon and Northern Lights. We celebrated 'Little Christmas' [Advent] here yesterday with music, song, porridge, and 'coffee.' Food is fine here—a couple of times we have even had fish soup with turbot—the largest one weighed 13.5 kilos and was 114 centimeters long! Yesterday, we had moose steak! By the way, would you have time to go to the hobby shop some time and get me something fun for our Christmas celebration? And have you received the nine grouse I sent last week?"

In the fall of 1941, we returned back to our apartment in Helsinki. Christmas came, and with it, a letter from Lale: "Well, I wish you a peaceful Christmas from the bottom of my heart. Let's hope there will be peace in the country next Christmas and that we can all be together then. For now, we'll only be so in our thoughts." And he added: "By the way, did you get my letter, where I wrote about the reindeer blood and thanked you for the

package of clothes and the apples? Today, I sent you a package of biscuits. A couple of days ago, a package should have been sent to you from Lieksa with moose meat."

Nunni answered: "You won't be here for Christmas, I had guessed as much, but still, it's hard to think that this is the second Christmas at war—of course, we are well and shouldn't complain. What a blessing children are, they rejoice over everything! Right now, they are playing such beautiful music on the radio, I miss you so very much—best to stop here."

∽

By now, any amount of censorship could not hide the truth: the German war effort was in deep trouble. Those Finnish politicians who had dreamt about a "Greater Finland" were waking up to reality. When news came in January 1943 that the German Sixth Army had capitulated in Stalingrad, where the few surviving Nazi troops were in a pitiful condition, it began to dawn on everyone that Hitler would eventually be defeated. The scene was set for the last act of Finland's tragic war against the Soviet Union. But not even the political leaders of the country were able to foresee the magnitude of the catastrophe that was coming. Stalin's sledgehammer was poised to strike.

Stalin Strikes

W E WERE SURVIVING. Thanks to Nunni's and Lale's efforts, and thanks to Riikka's heroics in the kitchen, we were surviving. We were getting used to the nights in the bomb shelter, to the blacked-out city, to the scarcities, even to the fear. And once in a while, Lale came on leave: those days were feasts.

We had left our home twice during the war years: once at the outbreak of the Winter War, and then once again when the Continuation War broke out. We had gotten used to living in new places and to not knowing when we would return. And then we did come back to Helsinki, and although we were afraid of the bombs, this is where we hoped to stay until the war was over. Little did we know that all this was just the beginning of our wanderings.

On a cold December night, as 1943 turned into 1944, we listened to the President's traditional solemn radio address to the people. The apartment was cold as usual. My mother had lit a fire in the fireplace, and now we took turns putting our New Year's "luck"—a piece of tin—in a ladle and, holding it over the glowing coals, watching as the tin melted into a thick, silvery liquid. Then, a quick flick of the wrist over the waiting bucket of cold water as we shouted our name, and the molten tin would solidify in the water: our "luck" for the coming year.

My mother pretended to read good tidings into the shin-

ing tin shapes: here is Papi coming home, here is food coming our way, and look! Here is a fancy dress for Maj! But her mood was somber. More soldiers were dying at the front every day and the food situation was growing even worse. Schools, only intermittently in session, were replaced by an effort at "long-distance learning" via lessons published in newspapers. My sister and her friends had to accept the fact that the government had forbidden dancing. They were working hard to collect points for an "iron spade," a small brooch given for civilian work on the home front: harvesting potatoes, collecting firewood, babysitting, helping the elderly. I gathered pinecones for our fireplace. Riikka, in her kitchen domain, where even my mother wasn't always welcome, did her very best to produce tasty meals with whatever little was available. The daily refrain was: finish everything on your plate!

But what about that Indian man, I wondered, whom they wrote so much about in the papers? He was a grown-up man, this Gandhi. And he refused to finish what was on his plate, as I was always told to do! I sat down and wrote an appeal, which echoed my mother's style: "Gandhi dear," I printed in earnest block letters, "won't you please eat." Instead of troubling my head with explanations about hunger strikes and civil disobedience, my mother put the letter in an envelope and said she would mail it to India. She didn't, of course, but in the month when the Royal Air Force dropped 2,300 tons of bombs on Berlin and the German two-year-long siege of Leningrad was finally lifted, that letter was the beginning of something new for me: an awareness of a bigger world out there that did not end with Sweden, Finland, or even Russia.

We could probably have continued on in this manner for a while longer. But then, on February 6, 1944, everything changed. On that night, the Russians carried out the first of three large-scale bomb attacks aimed at terrorizing the civilian population of Helsinki.

With more than 2,100 aircraft directly under his command, Stalin set out to destroy the city and force the Finns to sue for peace. Wave after wave of airplanes, in formations of fifty or sixty, thundered in from all directions. Helsinki's air defenses, however, were prepared for this blitz. A barrage of modern anti-aircraft guns procured from Germany greeted the attacking planes, and a "ghost city" of burning firewood depots, as well as searchlights far from the city, tricked some of them into dropping their bombs on the surrounding forests. Only five percent of the bombs hit targets in the city itself, lit up by clusters of Russian tracer bombs that intermittently turned night into day. Compared to the Allied bombings of continental European cities, Helsinki got off easy. Nevertheless, one hundred civilians were killed, and the hospitals filled up with wounded women and children.

My parents immediately realized living in Helsinki was no longer an option. Schools closed, and everybody prepared for the inevitable second round of bombs. On February 8, the head of Helsinki's air defense urged civilians to leave the city. Once again, we packed our bags. This time, we headed for Aunt Biggi's and Uncle Bert's summer place, an hour's bus ride east of the city. I remember guiltily sneaking in a small thanks to the Russians in my evening prayer for this chance to spend time in the country with my older cousins Torre and Ulf, whom I adored despite their constant teasing.

Getting there turned out to be more of a problem than we had anticipated. Even under normal circumstances, using public transportation in wartime Finland was quite an undertaking. The only way to get around, since the army had requisitioned most private cars, was by bus or by train. There was virtually no fuel in the country, so cars and buses sputtered ahead, equipped with their cumbersome "gazogene" burners that converted wood chips to gas. Even the President's Cadillac had one of those. But they were unreliable, and only half as effective as ordinary

gas engines. Timetables were nonexistent. One just stood by the roadside waiting for a particular bus, and hoped for the best.

So that was what we did, suitcases in hand, after the first large-scale bombing raid on Helsinki. My sister and I were wearing our white snow-capes; my mother had draped a white sheet around her. Our breaths formed big clouds in the cold air. No Russians would spot us. Next to us, however, there was a family waiting for the same bus, and they wore black.

The bus finally arrived, clattering to a stop. The driver got out and grabbed a long iron poker. His face and hands were soot black, and now the wood-gas barrel had to be coaxed to burn vigorously once more. I watched him climb up and open the lid as the air filled with smoke, sparks and flames. Undeterred, he reached into the barrel and stirred it with his poker to break up the charcoal blocking the engine, until he was satisfied.

"Let's see," he said. "Maybe she'll go downhill, but before the hill leading up to Sundström's shop, you'll all have to get out and push."

ᝈ

Ten days after our arrival at Aunt Biggi's, another wave of airplanes with even more bombs hit Helsinki. Again, the air defense proved effective: of 3,500 bombs, only 130 hit the city and casualties were light. And then, on February 26, came the final, most devastating attack. For twelve hours, wave after wave of planes hit the city. But even now, the air defense system performed well. Only 1,000 of a total of 16,000 bombs actually found their target. Most of them fell on the frozen sea surrounding the city, or in uninhabited areas. But with six percent of its buildings destroyed and hundreds of civilians killed and wounded, Helsinki looked like a doomed city. How long, people asked themselves, would our air defenses be able to repeal attacks on this scale?

Then, as abruptly as they had started, the Soviet air attacks stopped. Unbeknownst to us at the time, the Finns had scored another coup. They had captured a Russian spy whose job it had been to report to Moscow on the effects of the bombings, and were now using him in a clever counter-espionage move. In a pre-satellite era, Stalin had no way of knowing what kind of damage his air raids had caused. His man in Helsinki now assured him that the city had been thoroughly destroyed. It is likely this early misinformation was later corrected. Nevertheless, seven months later, when the Russian Control Commission arrived in Helsinki to oversee the implementation of the cease-fire agreement, they expressed their astonishment at how fast the Finns had been able to rebuild their city.

<p style="text-align:center">ᥫ᭡</p>

Out in the country during the bombings, my mother and my aunt were beginning to wonder if we had moved far enough away from Helsinki. But for my sister and my two cousins, the airplanes and the tracer bombs and the explosions provided much excitement. My sister wrote another breathless letter to her friend Hecko:

"Oh my God! They've been bombing again! It was awful even here! We sat in the cellar and bombs fell three kilometers from here—and they dropped five tracer bombs outside our house. One tracer dud fell right close to us. So the next day my cousins and I took about a tablespoon of the phosphorus and put it on a rock in the forest and set fire to it. Oh my God what a fire! Flames two meters high!"

It was during our stay with my aunt that my cousins and my sister, all several years older, taught me to sing a popular song. I loved to sing, and would climb up on a chair and belt it out, to the tune of "Lili Marlene":

First we'll capture Goebbels, grab him by the throat,
Then we'll get to Göring and throw him in a moat,
Then we'll hang Hitler, put a stop
Both to that jerk, and Ribbentrop.
The world will be so fine, without those four big swine!

I had never heard any adult person say anything good about Hitler, and was a little surprised when they told me to be careful and not sing this song around people I didn't know. First Gandhi, and now this, I thought. Grownups were strange. Didn't everyone know that Hitler was mad? Lale had said it himself, even though he had told me never to say anything bad about people: Hitler was *förryckt*.

<p style="text-align:center">❧</p>

It was shortly after the phosphorus incident that I overheard Uncle Bert scolding my cousins in a white fury. I had never heard him raise his voice before. But this time, he was screaming at them, and Aunt Biggi was staring down at her knitting, looking frightened.

"This is simply the most idiotic thing I have heard of! You go straight back and apologize, do you hear? Apologize, and tell them you'll never do anything like this again. I am ashamed of you!"

What had caused all this fury was that, down the road from us, there lived a family who was Jewish. They were acquainted with Uncle Bert and his family and had a son who was the age of the younger of my cousins. My cousins and two of their friends decided to play a joke on them. They marched down to the front of their house and started belting out the Horst Wessel song, the official anthem of the Nazi party. Someone inside had peeked through the window, recognized my cousins, and called Uncle Bert.

In a wonderful twist of history, my younger cousin Ulf's daughter is now teaching in a Human Rights program at a university in Finland. The Jewish young man who was inside that house that night used to be her boss.

<center>᠙</center>

In early December 1943, the first meeting of the Big Three, the "Grand Alliance," took place in Tehran, in greatest secrecy. Amid proclamations of friendship and toasts to Churchill, who was turning sixty-nine, they discussed the best strategy to bring the Germans to their heels. Prime Minister Churchill of Britain and U.S President Roosevelt, who were meeting Marshal Stalin for the first time, promised they would ease the pressure on the Russian troops fighting in the east by implementing their plan—Operation Overlord—to invade France. Originally, this was to have taken place in May; it was postponed until June. In their deliberations, they also discussed Finland: what was to be done about this stubborn co-belligerent of Germany's? Stalin had assured his colleagues that he had no plans to annex the country. But he did advise them of his wish to teach the Finns "a lesson."

During the spring of 1944, the Soviets and the Finns made some efforts to end the war. But the Finns would not agree to the Soviet demands of unconditional surrender. Finland had hundreds of thousands of soldiers deep in eastern Karelia and on the Karelian Isthmus, and if needed, the country was still capable of raising more troops. Trying to reach a separate peace with the Soviet Union was fraught with risk: how would the Germans react? Finland needed their weapons and their help, and Germany had several divisions of troops on Finnish soil. In addition, the food situation in the country had grown even more severe, and Finland was relying heavily on provisions imported from Germany. By this time, however, more voices were being raised in favor of entering into peace negotiations with Russia.

Field Marshal Mannerheim initially disagreed. It was his firm conviction that Finland would only survive as an independent nation if she resisted for as long as possible. The fighting in the east intensified and so did the bombings of Finnish cities.

Three days after the Allied landings in Normandy, on June 9, 1944, Stalin began the "lesson" that he had talked about in Tehran. The Soviet army staged a massive attack on the Karelian Isthmus. Approximately 450,000 Soviet troops with 1,000 heavy tanks and 10,000 cannon pressed the desperate Finns back toward the west. A thousand Soviet airplanes blasted Finnish positions. This time of year, there was no darkness to hide in, nor any snow or cold to slow the Soviet advance. In the face of overwhelming superiority both in the air and on the ground, the Finnish defensive lines on the eastern front crumbled. Viipuri, symbol of the early Finnish successes in the war, was soon back in Soviet hands. The Finns took heavy casualties: the pages of death notices and obituaries in the daily papers multiplied.

But the army regrouped, and then, in Tali and in Ihantala on the eastern front, the scene was set for the biggest battle in the history of Nordic warfare. In that theater, fifty thousand Finnish troops, assisted by German airplanes, were facing a Russian force three times that size, in a battle that lasted for more than three weeks. By the middle of July, Stalin had expected the country to surrender. Finland would finally, contrary to his assurances in Tehran, be his. Instead, in the face of stiff opposition, he ordered a stop to the Soviet advance. He would deal with Finland later. At the moment, he had bigger things in mind: he needed his troops to join the Allied race to Berlin. The Finns got a short breather, and a crucial dose of renewed hope.

In the face of the near collapse of the Finnish defenses, and with the certainty of a renewed attack, there were two alternatives for Finland: fight on, with dwindling resources, or sue for peace before the country was forced to capitulate. Mannerheim,

as well as the government, was now inclined to use the lull in the fighting to send a new peace feeler to Moscow.

But before this could happen, there was the matter of a promise President Ryti had made to the Germans, in a personal letter of June 26 to Hitler: no peace talks with the Soviets without Germany's agreement. It was time for delicate political hair-splitting, and Ryti was the willing victim. The Finns declared that Ryti had personally entered into the agreement with the Germans, and that this did not involve the Finnish state. In fact, no one had countersigned his letter to Hitler stating he would fight to the end on the German side. Constitutionally, therefore, the letter was meaningless, and Ryti knew this. Thus, a new President would be free to act as he saw fit. Ryti declared himself willing to resign the Presidency if Mannerheim would take over. In early August 1944, Ryti resigned and the bone-tired and ailing Marshal Mannerheim reluctantly accepted the Presidency of the country. At that point, he was seventy-seven years old.

As he emerged from the House of Parliament in Helsinki after the swearing-in ceremony, a silent throng of thousands greeted him. The country's fate was now in his hands. Among the hundreds of citizens who wrote to him to wish him well was the man who would succeed him as President, J.K. Paasikivi:

> Highly esteemed Brother,
>
> An enormous burden has now been added to the rest of your heavy duties. I feel for you personally. But with regard to what is best for the country, I cannot hide my satisfaction over the turn of events.
>
> From the bottom of my heart, I wish you all possible success. I do not wish to congratulate you.
>
> May it be possible, under your leadership, to guide the country out of the war, even under the conditions that are now available to us, and save what can be saved

before the Russians—if only for reasons of Big Power prestige—feel that they have to crush us.

With heartfelt greetings,

Yours always,

J.K. Paasikivi

<p style="text-align:center">∽</p>

Forming a cabinet under the fractious political conditions in August 1944 was no easy task for Mannerheim. Some politicians remained pro-German; others were willing to go far in making concessions to the Russians. Finally, the elderly and ailing Antti Hackzell accepted the post as Prime Minister, and a coalition government set about preparing for the onerous negotiations with Moscow.

But before Finland could enter into negotiations, there had to be an official break with Hitler's Germany. This was a Soviet precondition. And not only that: the Finns were to see to it that the German troops on Finnish soil—the whole Twentieth Mountain Army in northern Finland of more than 200,000 troops—would retreat from the country within a matter of two weeks. The timing was to start from the moment the Finns accepted the peace conditions. If the Germans had not left Finnish soil within that period—which was a logistical impossibility given their numbers—then the Finns were to consider the Germans as prisoners of war and take action to detain them.

It was a tall order, but there was no other way. The Germans suspected what was about to happen and contacted Mannerheim, trying to reassure him of the continuing strength of the German Wehrmacht. Mannerheim, much to the Germans' distress, refused to enter into substantive military discussions. He wrote a letter to Hitler, stating Finland's position. "I consider it my duty," he said, "to lead my people out of the war," and he asked for the Führer's understanding for the predicament of the Finns. He never received a reply.

The breach with Germany was now a fact. Finland would no longer go down with Germany in the military crash that seemed inevitable. She could enter into peace negotiations as an independent nation, the only one on the losing side that was never occupied by another power. But what conditions would Moscow impose? Were the Finns even in a negotiating position at all? Was this just a prelude to a Russian occupation?

<center>℘</center>

In early September, a Finnish delegation headed by Prime Minister Hackzell took a train to the quiet front, where, on September 7, they crossed by foot to the enemy side on a desolate stretch of land. They were met by Soviet officials and flown to Moscow. Molotov kept them waiting until the evening of September 14, when he finally received them. Meanwhile, the clock had started ticking for the Finns to rid themselves of the German troops on Finnish soil. It was a war of nerves.

Earlier that afternoon, Prime Minister Hackzell had visited Molotov. That is when he learned that the Soviets demanded an area west of Helsinki named Porkkala as a military base for a period of fifty years. No one had suspected this, and it came as a profound shock for Hackzell. A strong military base less than twenty kilometers from the nation's capital would give the Russians a chance to occupy Finland whenever they wished. Back at the hotel, he dictated a memo. Then he took a bath. A few hours before the negotiations were to start, the head of Finland's delegation was found in the bathtub, paralyzed by a massive stroke.

<center>℘</center>

Finland was a dancing lady. Anyone who looked at a map could see that she was. She was my dancing lady, with her skirts billowing out, her arms stretched way up over her head, her head cocked slightly to one side. She was twirling, and singing and

laughing. She was my country, she was my dancing lady, and now something terrible was about to happen to her. She was going to lose one of her arms, the one closest to Russia. And she was also going to lose part of her billowing skirt. You could see it on the maps in the newspaper. The adults were somber. My friend's mother was crying. Her husband had gone to the war to fight the Russians, and he hadn't come back as he had promised. He had gone to fight, and so had my Papi, and still, Finland the dancing lady was going to lose her arm and a part of her skirt.

&

As the Prime Minister in a Moscow hospital sank deeper into a coma and the Foreign Minister Carl Enckell arrived from Helsinki to head the delegation, Molotov spelled out the conditions for a cease-fire. They were even harsher than expected. In addition to having to lease the Porkkala area for fifty years, Finland would have to approve the border as it was drawn after the Winter War. The Petsamo area in the northeast, which contained vast nickel deposits, was to be ceded to the Soviet Union, as well as all of Karelia. In addition, the country would have to pay the Soviet Union, within a period of six years, a sum of three hundred million dollars in war reparations. "War criminals" would be prosecuted, and there would be an Allied—in practice a Russian—"Control Commission" in place to supervise the implementation of the agreement. This commission had considerable powers: if things did not go according to their wishes, they could always threaten a military intervention.

Last but not least, there was the matter of the German troops. If they hadn't left by the appointed time, they were to be taken prisoner and handed over to the Allies. At the same time, the Finnish army of 600,000 men in uniform had to be demobilized.

Could Finland accept these conditions? The country was in the worst possible position: alone, facing crushing peace condi-

tions. She had lost over 80,000 soldiers, or 2.5 percent of the population. According to military estimates, the Finnish armed forces might be able to hold out for three months, but not longer, if the war continued. Moscow did not leave much time for discussion. On September 18, an impatient Molotov posed an ultimatum: the cease-fire agreement would have to be signed in its present form by noon the next day, or the Red Army would move in. Mannerheim called the cabinet for a five a.m. meeting the following morning. After voicing his deep misgivings, Ernst von Born, who had taken over as Prime Minister after Hackzell, spoke in favor of accepting the peace conditions, come what may. That same evening, von Born spoke to the Finnish people on the radio. In a pointed understatement, he noted that opinions of what is right and what is wrong "turn out to vary a great deal under the present circumstances." But the Finnish people, he said, have no other choice than to make the best they can of their predicament.

The cease-fire agreement between the Soviet Union and Finland was front-page news even in New York and Washington papers. In contrast to Britain, the U.S. had never declared war on Finland—although it had broken diplomatic relations—and had expressed an understanding of Finland's predicament. The fact that Finland had now broken its connection with Nazi Germany was seen as additional proof that Hitler's forces were about to crumble. Finland was the canary in the coalmine, and the singing had stopped. This was a good omen for the Allies in the coming decisive battles on the European continent.

<p style="text-align:center">❧</p>

In the north of Finland, the German troops and their commanders followed this news with rising concern. For over three years, the Twentieth Mountain Army, under the popular Bavarian, General Dietl, had been stationed in Finnish Lapland, the northernmost and least populated province of the country

(part of the larger geographical area of Lapland which spans four countries).

They had fought alongside the Finns; some Finnish troops were initially under German command. They had generally gotten along well with the local population. And now, quite abruptly, they were forced to leave. How, in this vast country of open tundra and fells and few roads, was this going to happen within the appointed time?

And my parents' reaction to all these difficulties—the scarcities, the uncertain future of their country, the years and months they had to spend apart?

They decided to have another child! My mother was already pregnant at the time we left our apartment for her sister's summer place outside Helsinki, but it was early and she hadn't told anybody yet. And then, during one of the bombing raids on Helsinki that lit up our western sky, I woke up and needed to go to the bathroom. I turned on the light and looked around: the toilet bowl was full of blood.

Everyone was up. The door to my mother's bedroom was ajar and she was in her bed; my aunt emerged from the room in her robe and the hair net she always wore at night, carrying a pail and a mop. The water in the pail was bloody, too. Uncle Bert was on the phone, calling the doctor.

What was going on? Panic gripped my throat. My sister was sitting in the living room, looking worried, when she noticed me.

"Don't worry, everything will be all right. Mami is bleeding, women bleed sometimes. Come, let's go to bed."

The next morning, Nunni was still in bed, looking pale.

"Let me explain what happened last night. You were going to have a little brother, or a little sister. But sometimes, things don't happen the way we hope. We don't know why. So now we just have to hope that it can happen again."

℀

As the front was threatening to cave in before the Russian on-slaught, but before the cease-fire negotiations had gotten under way, my father decided that we needed to leave Aunt Biggi's country place and head north once again. I did not want to leave. Yes, the western sky would light up from the bombs over Helsinki, and Russian planes would fly over us, but this place felt safe: the garden patch and the black currant bushes and ap-ple trees and our rabbits and chickens, and the workshop where my cousins allowed me to hang around and watch them build their balsa model airplanes, which they hung, when finished and painted, from the ceiling like exotic fruit: Bristol Blenheim, Stirling, Junkers, Hawker Hurricane, Messerschmitt. But Lale said it wasn't safe, and so leave we did, repeating the long train journey with our suitcases for the third time. But this time we went even further north than we had before. In mid-June, we ended up on a farmstead near the small town of Ylitornio on the river that separates Finland from Sweden, a few miles from the Arctic Circle. Only much later, reading his letters to my mother, did I understand why my father had asked us to find a place to live as close as possible to Sweden. Finland, he reasoned, might not have much time left as a free nation. In case the Soviets oc-cupied the country, we could cross the Tornio River into Swe-den and freedom. "Give Maj and Riikka written instructions with Svante's address [a Swedish colleague of Lale's] and phone number in Sweden, in case they have to cross the border without you," he warned my mother.

Lale was not the only one who worried about an imminent Soviet occupation. But even my cautious father could not have foreseen that he was sending his family straight into a future war zone.

CHAPTER SIX

To Lapland

UNBEKNOWNST TO my mother, three additional passengers snuck in and joined us on that journey to northern Finland, to the Province of Lapland: a pair of red-headed twins, named Gutter and Better, and their little bouncy friend, Anschovinchen Bonscheli. I had made it perfectly clear to my family that they were frequent visitors to our apartment in Helsinki. At times, there had to be three extra place settings at the dinner table, at other times, they simply phoned and long conversations ensued. Gutter and Better played the piano and Anschovinchen composed. Gutter had a tendency to hiccup, Better picked his nose, and Anschovinchen spoke with food in his mouth. They were a handful, and my loud conversations with them caused my sister, six years older, endless embarrassment in front of her friends.

Why should that be so? I wondered. They took up no room. They ate none of the food that was so hard to come by. And they never objected to being woken up in the middle of the night to go down to the air raid shelter.

My three playmates were entirely imaginary, and they filled the void left after my real playmates had been scattered to the winds. As the refugee train chugged north into the realm of the midnight sun, the four of us hunkered down and tried to think

of ways to do away with Stalin and Molotov and get Papi home
from the war.

<p style="text-align:center">∾</p>

When we arrived at the Ylitornio train station, we were met
by the news that the place we thought we were going to was
already full of evacuees from southern Finland. Instead, a shy
girl at the station from another farmstead motioned us to come
with her. We left all our things at the station and walked with
her to the farmstead where she lived, a stone's throw from the
river that separates Finland from Sweden. The main building
was a low, prosperous-looking house on open land, surrounded
by outhouses and barns. I liked the place immediately: there was
a dog, a chicken-coop, and I could see three cows and a horse
grazing on a field nearby. There would be lots of things to do
here.

I was excited: we were now in Lapland. I knew something
about Lapland, since Nunni and Lale had made several trips
there to ski cross-country on the treeless, windswept Lapp
mountains the Scandinavians call fells. It was not a country, but
rather a geographical area made up of the northern parts of Fin-
land, Sweden, Norway and Russia. We were now in the Finnish
Province of Lapland, which constituted almost a third of the en-
tire country, stretching north all the way to the Arctic Sea. I also
knew that Lapps lived in Lapland, and that they were different
from Finns. They were the original inhabitants of Finland, who
had gradually been pushed farther and farther north as the Finns
moved in. They had their own language and they preferred to
call themselves Sámi. They were the people of the wide open
spaces who kept reindeer, who had colorful costumes, who lived
in tepee-like dwellings called *kotas*, and who—so Nunni told
me—knew many of nature's mysterious secrets. I was thrilled to
be in Lapland, but I didn't see any Lapps in Ylitornio. The fam-
ily who took us in were Finns. The real Lapps live farther north,

Nunni said. In summer they are up on the open tundra, on the fells, guarding their reindeer herds.

As soon as we got to the homestead, Gutter, Better, and Anschovinchen Bonscheli vanished into thin air. The Finnish-speaking family who took us in had five flesh-and-blood children, and other children lived near by. The land, bathed in the constant daylight of late June, was wide open with fields of barley and wheat, and the waters of the mighty Tornio River, just a five-minute walk from the farmstead, were full of fish. In the north, on the Finnish side, we could see the majestic silhouette of the Aavasaksa mountain, holy to the Lapps and a popular place to watch the setting midnight sun touch the horizon and then, as if pulled up by a magic string, start to rise again. In winter, the reverse would be true: this place and everything north of it would be plunged into constant darkness for several months. On the opposite side of the river was Sweden, and in Sweden, there was no war. There was peace, which meant it was out of the reach of Stalin and Molotov. They said that your windows didn't need to be covered up at night in Sweden and that the apartments and houses were always warm and that you could have hot water anytime you liked.

But for now, this place was fine. "There are animals here," Nunni wrote to Lale, "the horse Erkki that allows the children to crawl under his belly and ride him to pasture, even Stina! There is a yellow cat, two dogs, three cows, a foal nearby, so you can see that life is worth living! I have offered to milk and take care of the cows and we'll get some milk to drink ourselves from a nearby farm—close enough to bike there."

My sister, in the early stages of puberty, didn't care much for animals. She complained to Hecko: "Isn't it horrible that there has to be war, when we are young and want to have fun? You probably think I'm stupid, but that's how I see it. I'm furious that I have to be here! We arrived yesterday: Mami, Aunt Biggi, Stina, Riikka, my cousin Ulf, and I. The train was awful, I can't

even describe how awful it was, we only had third-class tickets, and it took twenty-four hours to get here, instead of the usual ten. The world would be saved if England and the United States would stop helping Russia and started fighting them instead. I certainly would prefer Englishmen to Russians. Or what do you say? And the food situation is really horrible here. You would think it would be good, since we are so close to Sweden."

Nunni, in her first letter from Ylitornio to Lale, agreed: "The food situation is a bit tricky here, though. We get potatoes from the farm and, every other day, three liters of milk from the neighbor, but no meat, no vegetables. I think I'll go down to the river now and see if I can catch enough for a fish soup. And please, send a package as soon as possible with: the two small red pots with lids, the gray enameled pot, the coffee pot, and the frying pan. We don't have enough pots and pans here and there is nothing to buy."

Maj, always keen on having things look nice, wrote to Lale in a separate letter: "You should see what a beautifully set table we have now! Yesterday, mother and Aunt Biggi bought white plates, coffee cups with flowers on them, a real bread knife, a birch bark bread basket, and a glass pitcher for milk."

My father, who was in Helsinki on leave, wrote to Nunni: "I'm sending you a pair of pants to be patched. Wrapped in these pants there is a small saucepan with two eggs, surrounded by many layers of paper. Write immediately and tell me if they survived the journey. If there is time, I'll also send you another package with two cucumbers, some radishes and rhubarb, and the white enameled milk pail filled with salted Baltic herring."

"It's beautiful here," my mother answered. "The light in the morning, when I'm the only person about, is so luminous that I sometimes stop right in my tracks. The cows recognize me already and come when I call them—they even know their turn to be milked. Afterwards, when I walk home along the footpath with the steaming milk, I feel so at peace with nature, and I love you with all of my homesick heart."

The eggs didn't make it, though. When a second package with one dozen eggs arrived with six of them broken, and smelling, my father stopped the egg shipments.

<p style="text-align:center">℮℗</p>

Even a child, however, could not help noticing that something was wrong those last days of June and early July. Each day, trains were arriving from the Karelian front to the small Ylitornio railway station, and coffin after coffin was unloaded onto the platform. It was hot, and if there was a wind from the direction of the station, it carried a stench with it. On those days, my sister used to sit on the stoop and cover her nose with a handkerchief. She had gone to the station on her bike to fetch the mail, and she told me sternly not to go near there.

"You won't like it. There are coffins on the platform, and they stink."

"How do you know Papi won't be in one of those coffins?" I wondered aloud.

"Because he promised us that he would come back home, silly," my sister assured me.

The church bells were ringing day and night, calling people to funerals. The coffins needed to be buried quickly. Some bore the inscription: "Should not be opened." My mother, in her black skirt and white blouse, bicycled from one funeral to another, and made condolence visits to widows, drinking the bitter-tasting coffee substitute with them in grieving silence. "They are amazing, these women," she wrote to Lale, "the way they manage everything on their farms in the absence of their husbands or sons. They talk about the casualties with such quiet dignity. Last Sunday, eight funerals and the church so full that people were left outside. Right now, the church bells are ringing again—new coffins into the ground—it has to happen as soon as they get here."

I kept watching my mother carefully. Had she cried? Would she ask us to come to the bedroom, and tell us something

terrible? That fear sometimes made me wake up with a start. But mother kept on milking the cows, bicycling to funerals, and the trains kept coming. One day before my seventh birthday, she came running to me in the yard, beaming:

"Telegram for you! Happy birthday telegram from Papi!"

I was just learning to read. Yes, it was true. It said PAPI.

Overjoyed, I grabbed the paper, summoned Gutter, Better, and Anschovinchen Bonscheli, and together we put the telegram on a chair in the corner of the big room and, using it as sheet music, made up a happy Papi song.

The next day, the telegram occupied the place of honor among my birthday presents, which included an orange from my cousin Ulf and a cup full of sun-ripened arctic berries my sister had picked on the island in the middle of the river.

"Rubus arcticus," Maj said, taking over from Lale, who surely would have taught us the Latin binomial had he been there. "The best berries on earth." They looked like small rubies, so delicate in texture that some people picked them by inserting a needle into them in order not to crush them with their fingers. Even back then, they were a rarity. Putting them into my mouth one by one and savoring their delicate sweetness, I felt like a princess. A Princess of Lapland.

Then came time for the yearly birthday ritual: the nightgown picture. This was another one of Nunni's long-term projects. When my sister was born, she bought her a child's cotton nightgown, many sizes too big for a newborn. On Maj's second birthday, when she could stand up, Nunni dressed her in this nightgown and took her photograph. She continued this every year, and when I was born and could stand up, she started the same series of pictures of me, wearing the same nightgown. She did not miss a single summer of my sister's birthdays, in May, or mine, in July—until we had grown so tall that the nightgown barely shielded us when we held it up.

So, on my seventh birthday, July 4, 1944, we walked down a ways toward the river, and Nunni snapped the picture. The

river glimmers in the background, and beyond it, barely visible through the summer haze, lies Sweden.

ↄ

The local population had greeted the German troops who arrived in Lapland in the fall of 1940 with a certain amount of suspicion. Few foreigners ever ventured into this vast and sparsely populated area. What precisely were these strangers there for? How long were they going to stay? But over time, as the contacts between the German soldiers and the Finns multiplied, the Finns came to feel more at ease. After all, they knew they needed help against the common enemy, the Soviets, whose raids across the border in the northeast had caused thousands of locals to flee their villages in terror. Many of the northern Finns regarded the German soldiers as a reassuring presence. And there was an enormous number of them: by the time the whole Twentieth Mountain Army was in place with its 220,000 men, it had more than doubled the population of Finnish Lapland.

Most of the German troops were stationed in the eastern border areas of Lapland. They were there for a simple strategic reason: to secure access to the Petsamo nickel mines that, from 1943 onwards, provided eighty percent of the nickel needed for the German war industries. Without the Petsamo mine by the Arctic Sea, Germany would have been unable to produce more than a fraction of its heavy tanks now rolling through Europe. Petsamo was situated in a fateful geographic position for the Germans. Because it was so close to the Soviet border, it forced Hitler to deploy more troops there than he really could afford, and to keep them there after the Nazi war effort had already begun to founder on the European continent.

But the German soldiers were not only in Petsamo; they were present in many of the larger communities of the district as well. In this sparsely populated region, they were a formidable presence. At the time, the population of Finnish Lapland was a little over 150,000. The German army in the area, at peak

strength, reached 220,000 men. The capital of Lapland, Rovani-
emi, served as their headquarters and there, almost every other
inhabitant was a German soldier. The German race theorists
had been working overtime to find some ethnic links between
the Finns and the Germans, and had finally come up with a
way to locate them in a favorable spot on the Nazi racial charts
based less on race than on character. The Finns, it was said,
were a trustworthy and tough people. The men made excellent
soldiers; their women were brave and warmhearted. They felt
a fierce loyalty to their country, the race theorists claimed, and
would defend it to their last drop of blood. The Finns were a
brother people, the German soldiers were told, and in the fu-
ture Thousand Year Reich they would be given a prominent
place.

But here, in Lapland under the midnight sun, all this trans-
lated into an uneasy coexistence, lasting for three years, from
which both parties drew some benefits. The Germans had
money, with which they bought reindeer meat and other food,
firewood, and hay for their horses from the Finns. They hired
them, and paid them handsome wages. They rented houses and
rooms from them, and leased land to construct barracks. With
the Germans came improvements in the local infrastructure of
roads and electricity. Buildings were repaired, German vehicles
were used to transport firewood, German horses were lent to
help with plowing and sowing, German gas helped keep Finnish
vehicles on the roads. The Lapp economy, considering this was
wartime, was doing well.

In contrast to Norway, where the German troops were an
occupying force and generally hated by the local population,
in Finland they were urged to behave as "guests." High-rank-
ing German officers participated in the celebration of Finnish
official holidays, such as Independence Day or Veterans' Day,
when speeches and toasts in Finnish and German were made
and the national anthems of both countries sung. Less visibly to
the locals, Finnish military personnel were present at German

observances of national holidays, such as the one marking Hitler's ascent to power and his birthday.

The German presence in Lapland also meant a sudden increase in cultural activities. German military bands participated in Finnish celebrations of all kinds: they gave concerts on Midsummer Night's Eve, and they played at prize ceremonies, at sports events, at children's festivals, and in veterans' hospitals.

There were offerings of high culture as well, rare in Lapland until that point. In Rovaniemi in 1942, the Germans constructed a *Haus der Kameradschaft* (Friendship House) complete with a concert hall for 350 people. How many northern Finnish lumberjacks and farmers, subjected to hours of Wagner with no intermission played by some visiting German symphony orchestra, escaped into the Lapland darkness, vowing never to set their foot in a concert hall again?

But the Germans did offer lighter fare as well. Who, in Lapland, had ever dreamed they would be able to see or listen to artists like Rosita Serrano, Ilse Werner, or Lizzie Waldmüller, other than on the German radio station broadcasting in Lapland? But here they were, in the Haus der Kameradschaft, in person! And here, as well as in most of the smaller communities where Germans were present, you could also see movies, some of them in full color.

And then there were sports. Part of the Mountain Army's soldiers came from Austria, and excellent downhill skiers were among them. Races were organized on the wide-open faces of the Lapp fells. On one occasion, the local paper reported that there were so many spectators that the snow-covered sides of the fells "turned black." In cross-country events, the Finns dominated. They skied, according to a German report, "like devils." They were also amused by some of the Germans' ineptness on skis, and gave them lessons.

In summer, soccer teams were formed, and the Germans constructed a soccer field—Rommel Field—outside of Rovaniemi where "friendship games" were played.

The Germans initiated and participated in charity events to help Finnish war orphans, wounded veterans, and widows. The popular and jovial Commander-in-Chief of the Mountain Army, General Dietl, was frequently present at such events, even in small communities, and helped distribute presents, candy, and toys. All this happened far from where we were. I only knew that two Germans were manning the local telephone exchange and that the farmers' daughters were told to pay no attention to them.

On the medical front, too, the Finns stood to gain from the German presence. In the Lapland wilderness, local doctors and hospitals were few and far between. The Germans brought in skilled doctors, dentists, and veterinarians, who offered assistance to the locals as well. You didn't need to be employed by the German forces to qualify for help.

Clearly, all of this gradually lessened the northern Finns' suspicions. Years later, I remember talking to the father of a friend, who had been a high-ranking military officer in Lapland at the time. "You may say what you like about the Nazis," he said, "but I tell you: in Lapland, they were very correct. And not all of them were Nazis, either.... Of course," he added, "at the time, we didn't know about the deportations and the gas chambers."

But there were frictions as well. Problems arose mainly over women. The Germans and the Finns may have been a brother people, but in the name of racial purity, the Nazis discouraged German soldiers from entering into intimate relationships with Finnish women. Still, with their men folk gone to war, and the young Germans far from home and lonely, things were bound to happen. Many Finnish women lost their hearts to German soldiers, who were more than happy to forget the rules. For a young Finnish woman, a job with the German forces was frequently a job in name only: it was a life of parties and alcohol and access to food and clothing and travel with the troops, a life far more exciting than her existence in an isolated village in the Lapland wilderness had ever been. There was little point, people felt, in trying to hide this behind some job description: if

a local girl was seen socializing with a German soldier, what, besides sex, was going on, since they didn't even share a common language? If she was unmarried, the authorities tended to look the other way. In wartime, what would you expect? They came down harder on married women. A married woman with loose morals in Lapland could affect her husband's fighting spirit at the front, and that was dangerous. "It is regrettable," wrote a Rovaniemi paper, "that the Finnish woman betrays her honor and her country at a time when Finnish men are suffering the hardships and terrors of war at the front."

Few of these relationships ended in marriage. This was partly due to bureaucratic obstacles, and partly to the abrupt end of the whole German presence in Finland. But close to 1,000 children were born to Finnish mothers and German fathers, and stories about these "footprints of the Alpine boots" continued to linger long after their fathers had left the country. Girls named Ilse and Hannelore, boys named Fritz and Ernst were left behind. These Finnish-German children were largely left to grow up in peace, in stark contrast to the 12,000 children fathered by the Germans in Norway whose births the Nazis regarded as a boon for the Master Race—and who were later stigmatized by the Norwegians as symbols of cooperation with the occupiers.

<center>☙</center>

I remember being wary of the Germans in Ylitornio. There was something in the air, something not openly talked about at home. The eldest daughter on the farmstead worked in the local telephone exchange, which was manned by Germans. She went to dances organized by them, and came home to looks of quiet disapproval. My mother, who in a letter to my father described my sister as "on the verge of becoming a young woman," told Maj in no uncertain terms not to attend these dances. I don't remember my sister protesting much. But then, a few days later, she came to ask permission to go to a movie the Germans were showing in town.

"It's just a movie. Hillevi and Sinikka are going too. Please, please. I won't be late."

Nunni gave in, somewhat reluctantly, and off they went, on their bikes.

At eleven o'clock, the sun still high in the sky, Sinikka and Hillevi returned home, but Maj was nowhere in sight. "She'll be coming soon," the girls assured my mother. Another half-hour went by, no sister. It was past my bedtime, but under the midnight sun, ordinary rules don't apply. I stayed up, pretending to be busy drawing pictures, to see what Nunni would do.

Finally, she walked out and around the house where she could see the dirt road leading into town. Then she headed to her bicycle. I looked out the window, and just as Nunni was about to get on her bike, a small cloud of dust on the road announced some traffic. It was Maj, on her bike. But she was not alone. There was another bike, and after a short stop, that bike turned around.

I tried to make myself very small in order not to miss the conversation, but I was ordered to bed. So I stood by the door on the other side, cocking my ear.

I heard only snatches of their conversation. "I told you not to" and "you're a young woman now.... Not suitable." And my sister's voice, "nothing wrong,...Hansi is so nice."

Nobody shouted, and nobody cried. That wasn't the family style. The idea was to explain, to make sense, to understand. Nunni would be a tolerant and open-minded mother later in life as far as her daughters were concerned, but here, she had to take local opinion into consideration. We were guests, living at the farmstead at our hosts' pleasure. Appearances mattered.

I did not hear the end of the conversation. But I sneaked a look at my sister when she came to our room. She had cried.

ल

We are on a field raking hay under the scorching August sun. Two German soldiers on leave have joined the farmer and his

family to help. I'm taking a break to drink my lingonberry juice in the shade of a haystack and one of them comes to sit next to me. I stiffen and look away; he smiles. He is looking at me, at my long braids. I sneak a sideways look and notice tears in his eyes. He says something I can't understand. He searches his trouser pocket, and shows me a black and white photograph. It is wrinkled and yellowed and the picture of a girl is looking at me: a girl like me, with long braids.

"Meine Tochter," says the soldier. *"Verstehst Du? Meine Tochter,"* he says, and strokes my hair.

I look around. Nobody has noticed. And I decide: this isn't dangerous. But to be on the safe side, I will mention this only to Gutter and Better, and maybe to Anschovinschen Bonscheli.

<p align="center">∛</p>

In early August, the short northern summer was coming to an end. The fields of barley turned yellow, and everyone who was able to handle a pitchfork or a rake went out to help put the hay under cover while it was dry. There was a chill in the air, and the wind whistling from the north forced my mother to wear gloves and woolen long johns when she was milking the cows. When she wasn't caring for them, or roaming the forests picking berries or mushrooms, or patching Lale's shirts and turning frayed cuffs and collars, or unraveling old sweaters and knitting new ones for us, or fishing by the river, my mother wrote to my father. I can still see her, sitting at the corner table in the large living room by the window, writing. To me, this was very reassuring: there was still a Papi to write to, and he would answer soon, and there would be greetings to me.

"Today the oldest girl in the family and I left on our bikes," she wrote to my father, "ten kilometers, and then by boat across one arm of the river to the island in the middle of it. We cut and gathered hay all day, and then we biked home, got here just in time to milk the cows. My hands are shaking a bit now, it's been non-stop since six thirty this morning, but it's been a beautiful

day. Please send some vinegar, enough for five heads, all the kids have lice!"

Most of the time, my mother managed a positive tone in her letters, but sometimes she lapsed: "Thanks so much for the package but oh, must you always stick to the rules? Not one single line from you in all these packages! That's what I can't help looking for when the packages arrive—what if you stopped this cruel practice and smuggled in a small note with five words.... I'm so fed up with everything here. The flies are bothering me and I feel so restless—how long do we still need to be here? Patience, patience, you say, but to hell with patience and with trying to be a good girl. I should of course not mail this letter at all, and just write about cows and beautiful colors and that we are fine—or just go to bed and have a good cry. Why didn't you write today, I also expected you to call!

"I'm sorry for the above, but I've been adrift now for six months with children and suitcases and I have a feeling that you too are not exactly happy...

"On Sunday our farmer and I are getting up at five in the morning and taking the train to Kainuunkylä, from there it's a 16 kilometer bike ride to a moor where they say there are lots of cloudberries. Do you think it's all right to do this on account of the Russians, today they've been looking for Russian deserters around here? Let me know!

"Thanks for the rhubarb, and the three tomatoes. I've just had a whole one, wonderful! Please send me some more home-made soap, if there is any left.

"And what's this about Mannerheim becoming President, there is something political going on, right?"

There was indeed.

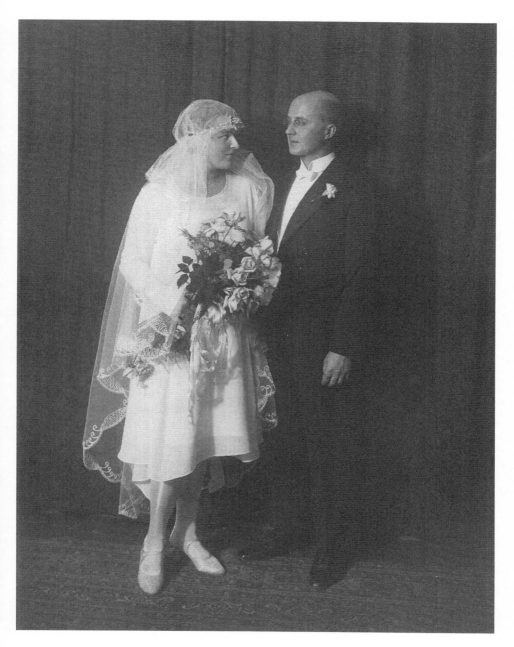

Nunni's and Lale's wedding day, 1928

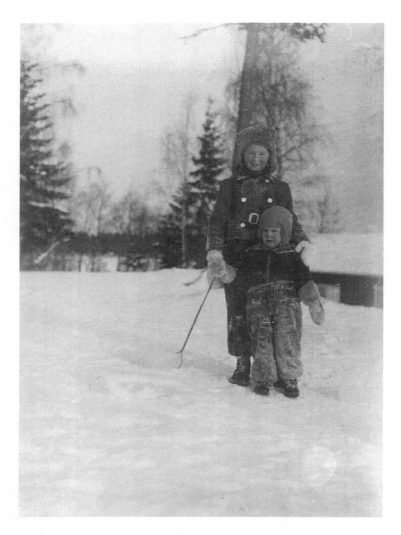

Maj and Stina, 1939

LEFT: *Grandma Nanny*

BELOW: *Stina's and Herant's wedding day, with Riikka, 1964*

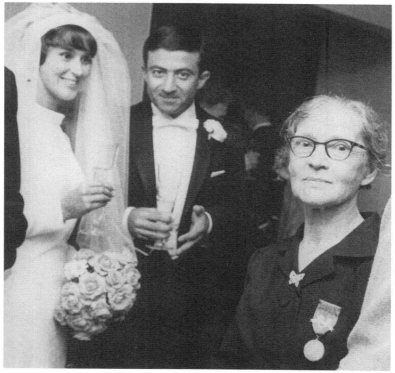

Finnish and German soldiers listening to a gramophone

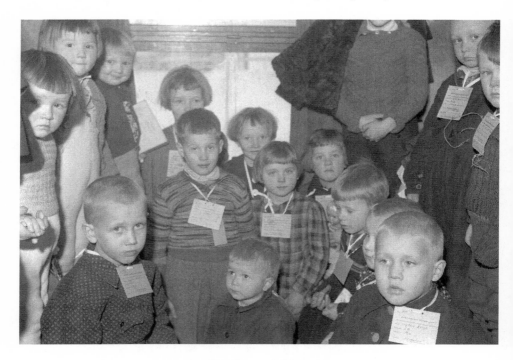

Finnish refugee child transport

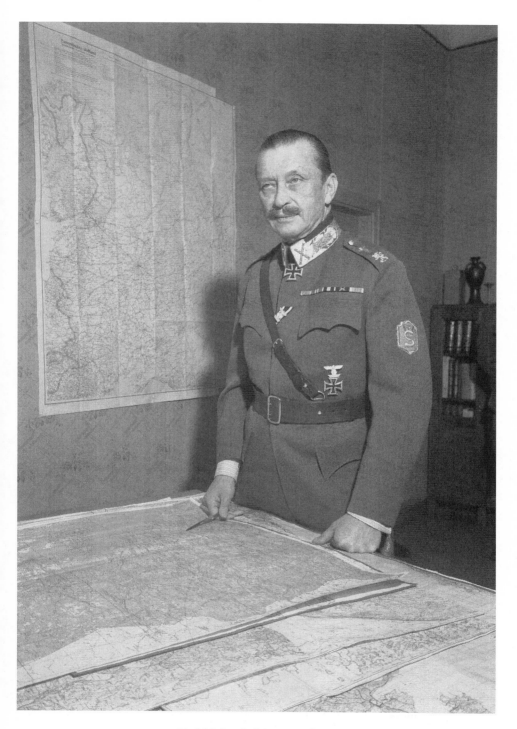

Field Marshal Mannerheim

President Risto Ryti

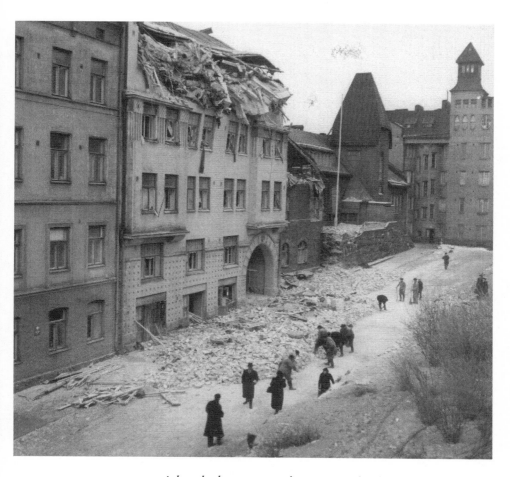

ABOVE: *A bombed apartment house in Helsinki*
BELOW: *An old refugee woman in Lapland*

Nunni milking

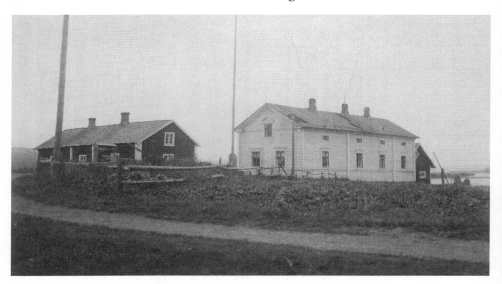

The farmstead in Ylitornio

Stina in her nightgown, Lapland, 1944

Cattle on the Lapland Road

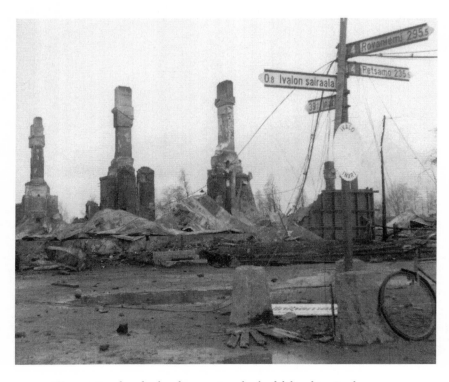

All over Lapland, the destruction looked like this. Ivalo, 1944.

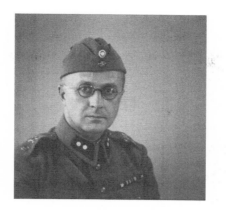

TOP: Lale in uniform
LEFT: Nunni and Maj, circa 1944
RIGHT: Nunni and Stina, circa 1944

*Lale and Nunni
in later life*

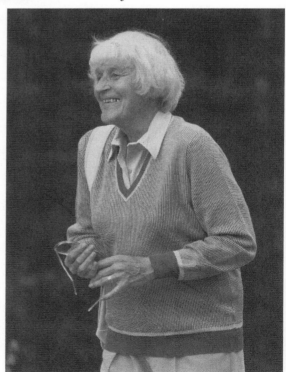

Lapland Empties

O N SEPTEMBER 19, 1944, with the ceasefire agreement between the Finns and the Soviets signed in Moscow, time was running out on the Finns in the north. There were still nine divisions of the German Twentieth Mountain Army in Finnish Lapland—220,000 men with heavy weapons, tanks, and huge amounts of supplies. In every little village and town in Finnish Lapland people were asking themselves what would happen next.

My mother feared the worst: "So now we have a cease-fire—the conditions are harsh, but I guess they could have been even worse. I just hope that this thorny question of the Germans could be solved without too many problems. Why can't they just agree on some sort of 'pretend war' and let the German troops pull out quickly?"

That was exactly what the Finnish High Command was hoping would happen. The troops would have a "maneuver." The Germans would withdraw to Norway, and Finnish troops would follow on their heels and occupy the areas they had just abandoned. It would be quick and tidy, and the civilian population would not suffer.

As a matter of fact, for some time Hitler had already been convinced that the Finns could not be trusted to keep fighting on the German side. He knew he would have to withdraw

his troops from Lapland, because he badly needed them on the Continent. In greatest secrecy, he issued an order to prepare for a withdrawal to northern Norway. Hitler's order must have caused a shock in the German headquarters in Rovaniemi. How to prepare for this, without the Finns noticing? The withdrawing troops would have to be supplied by sea from Norway. What if the Allies managed to disrupt that supply route? That would lead to a catastrophe: the Mountain Army of 220,000 men would starve to death on the frozen Lapp tundra, or—perhaps even worse to their mind—become prisoners of the Soviets.

Edouard Dietl was one of the few German generals who actually dared to contradict the Führer. He thought it would be easier to withdraw south through Finland, and said so to Hitler. The German navy and the German air force would not be able to supply that huge army as they withdrew toward Norway, he feared. The troops would run the risk of being met in Norway by Soviet troops brought in by sea, which would spell doom for the Twentieth Mountain Army. But Hitler insisted.

Dietl had arrived in Finland in 1942, after two years in northern Norway, and he was never able to forget his first winter in the Finnish wilderness. The troops had arrived before most of their supplies, and had had to endure that first winter out in the open. Dietl now imagined that the withdrawal might result in similar deprivations. But he was a soldier, and soldiers obey. During the winter of 1943–44, he set about improving Lapland's roads—partly using prisoner-of-war "volunteers"—and stocking up military supplies from northern Norway to northern Finland and the Petsamo nickel mines. And so the withdrawal from Lapland started, and it bought northern Finland a two-week reprieve.

⁑

On the Ylitornio farm, I was blissfully unaware of the political drama being played out. There was something much more important on my mind, and that was sex.

This was the season for impregnating the cows, so that by the next spring when the snow had thawed and the spring grass was fresh and green, the little calves would arrive into a friendly world. For this purpose, a bull was being led from farm to farm, and on a bright Sunday morning it was our cows' turn. Perhaps I wasn't meant to witness the lusty and short act that took place behind the cowshed, but one of my friends on the farm had alerted me and we had secured our places in the nearby bushes well in advance.

"Wait till you see the bull's thing," he whispered. "You won't believe how huge it is."

It was certainly worth the wait, but it was over almost before we knew it.

"Does it ever get stuck?" I wondered. "Inside?"

"Oh no," sighed my friend, pretending to be aghast at such ignorance but at the same time sounding a bit alarmed at the possibility. "I could show you how it works some time, if you like," he boasted. "If you'll come with me to the hayloft."

There had been talk at home about all this, because I had asked where babies came from. I had been satisfied with Nunni's explanation of how a little seed gets planted when a man and a woman love each other. But how did all this square with the bull and what I had just seen?

It would be easier to ask my sister rather than my mother, I thought.

"That bull had never even seen our cow before! How could he love the cow?"

My thirteen-year-old sister, whose hormones were raging, looked me straight in the eyes:

"Sometimes," she said, "it's just lust."

I decided I'd better stay away from the hayloft.

૭૩

Stalin and his people on the Helsinki-based and much hated Control Commission were not happy with the situation. They

wanted a war, and so far there had been no fighting. The Com-
mission was completely dominated by the Russians under
Stalin's "crown prince" Zhdanov—the man who had led the
1940 brutal Soviet purges in Estonia. The Russians wanted to
provoke war in the north. Perhaps they saw it as another way
to punish the Finns, but their main purpose was to weaken the
strength of the Germans, and to free up their own troops sta-
tioned in Lapland for the crucial battles still going on against
Germany on the European continent. With Finland vanquished
and the Germans gone from the north, the Soviets would have
1,000 kilometers less border to defend. The Russians also had
their own sights on the Petsamo nickel mines, and they wanted
the Finns to weaken the Germans on their behalf in preparation
for the coming Petsamo battle. As day after day passed without
any Finnish military action against the Germans, Stalin's irri-
tation grew. Zhdanov sent his officers to the Finnish military
headquarters in Mikkeli and demanded to see their plan for cap-
turing and imprisoning German soldiers.

There was no such plan. Mannerheim realized that Finland
had come close to the point where the Russians would accuse
the Finns of non-cooperation. The consequences for the country
would be disastrous. There was a feeling of doom in the Finnish
military headquarters. Mannerheim and his staff reportedly ate
their lunches in total silence, some of them not touching their
food. The threat from Russia was plain enough. But there was
also a threat from Germany to consider: could Hitler be plan-
ning a coup against Helsinki as a revenge for the Finns seeking a
separate peace with the Soviet Union?

Hitler did have such designs. The Germans would send a
military staff to Helsinki to replace the political leadership there.
This would work only if some Finnish troops would choose to
remain on the side of the Germans. But fortunately this split,
which could have made Finland into a battlefield between the
Russians and the Germans, never occurred. The Finnish army
never questioned Mannerheim's leadership or his goals. Some-

thing had to be done about the German troops in Lapland, and quickly.

Mannerheim's first move was to appoint General Hjalmar Siilasvuo, a hero from the days of the Winter War, to command the Finnish troops in the north. Siilasvuo was one of the commanders who had fought the Russians in Karelia. He had also led Finnish troops under German command in Lapland in 1941. He possessed an intimate knowledge of the German troops he was now going to fight. Since he had had severe differences with the Germans in Karelia, taking harsh action against them now would present no problem.

With the regular Finnish army about to be disbanded, Siilasvuo's troops would consist mainly of nineteen- and twenty-year-old recruits without battlefield experience. And these were the soldiers who were to take on the mighty German Mountain Army! An additional ominous development was the fact that the popular German commander, General Dietl, had recently been killed in an airplane crash on his return from a meeting with Hitler to discuss the situation in northern Finland. (There were rumors, never substantiated, that Hitler had had him killed.) Dietl had spent more than three years in the north, and he liked the Finns. Had he been in charge, the result might not have been such a disaster. But now he was gone, and replaced by a general with the sinister-sounding name of Lothar Rendulic, a lawyer interested in the classics but a hard-core Nazi with no emotional ties to the Finns, and no sympathy for their position. Embossed on some of the German soldiers' belt buckles were the words *Meine Ehre heißt Treue,* "My Honor Is My Loyalty." If the Finns were to be disloyal and fight their former brothers-in-arms, they would be severely punished.

છ

In the middle of all this political uncertainty, my father got a chance to visit us. He attended a forestry meeting in Rovaniemi, and from there, he took the postal bus down to Ylitornio. It had

been four months since we had seen him. His calm demeanor and quiet sense of humor had a calming effect on all of us. I spent those days drawing pictures for him, and proudly showing him that I had learned to write—in a manner of speaking—in the Finnish-language village school. He was amused to hear me speak the local dialect of Finnish I had picked up from my playmates, as I proudly explained to them who he was and what he was doing. Papi is a hero, I announced. He has helped stop the Russians. And now, I added with the help of Anschovinchen Bonscheli, he is in charge of Southern Finland, a little bit like a King down there. My friends on the farmstead had no problem accepting that he was a little bit like a King. They had never been outside the village and had vague notions of southern Finland. They asked me once if the moon shone down there in Helsinki, too.

The memory of Papi's strong hugs and the smell of pipe tobacco mixed with homemade soap sent me into a deep, dreamless sleep the night after he left.

As soon as Lale got back to Helsinki on September 17 he wrote to my mother describing some of the chaos that he had seen descending on Lapland:

"My dearest, thanks for those wonderful, cozy days with you. I'm home again after an adventurous trip. I got to Kemi all right, but had to wait there for the next train for almost three hours, instead of the supposed twenty minutes. That train was overcrowded, but after a lot of back and forth I managed to squeeze into the cattle car all the way to Oulu."

"Most of the Germans had already left Oulu by Friday, but in Kemi you could still see a few of them here and there around the station. Otherwise, all was quiet. But you know—it would have been impossible to try to get on that train with children and all our things."

A few days later came the news that the trains between the north and the south would no longer carry any mail. The only

remaining link for postal traffic was by sea. A barrier was about to descend separating us from Papi in Helsinki.

℘

Up in Ylitornio, my mother started packing our belongings. An order to empty Lapland of its entire civilian population of 168,000 people, along with over 50,000 cows and other livestock, had been issued in early September of 1944. The order originated with Mannerheim himself. He feared that widespread fighting would break out in Finnish Lapland between the Finns and the Germans. Before this happened, Lapland's civilians needed to get out of harm's way. Mannerheim summoned his Minister of the Interior, Kaarlo Hillilä, who was also the Governor of the Province of Lapland, to his presidential residence in Helsinki. "I've decided to evacuate the population of all of northern Finland," he told Hillilä. "Please write an evacuation order."

Hillilä did as he was told, and the order was written in a matter of minutes.

"You choose the people to organize this," Mannerheim continued. "My train for Headquarters is leaving soon."

A plan was quickly drawn up for what was to become the largest civilian evacuation ever in Scandinavian history. Part of the population of Finnish Lapland was to move south, into the region of Ostrobothnia. Another part—fifty thousand civilians—was to cross the border river into northern Sweden. Official permission to receive up to 100,000 Finnish refugees came promptly from the Swedes, a permission all the more remarkable since Sweden already had taken in thousands of Finnish children, wounded Finnish soldiers, refugees from Nazi-occupied Norway and Denmark, Jewish refugees from central Europe, as well as refugees from the Baltic states. No one could tell when, if ever, these new refugees would be able to return. Then an order went out to all Finnish Lapland's officials to remain on their jobs: in this fluid situation, no one was going to be able to

claim that the representatives of Finland, a sovereign country, had abandoned their positions.

On September 8, 1944, Lapland's inhabitants gathered around their radios to listen as a high district official, Gideon Nyholm, addressed the people just before the radio transmitter in the Lapland capital of Rovaniemi went off the air. Everyone on the farmstead, including me, had been summoned into the house to listen to an important radio message. My friends and I were annoyed to have to interrupt our game of hide and seek. But as soon as we saw the expression on the faces of the adults we knew: something frightening was about to happen.

"People of Lapland," intoned the somber voice of Mr. Nyholm, "as you have all read in the papers, events during these last days have accelerated very fast. The situation has now reached a point where we all have to leave our dearly beloved Lapland. As the radio station in Rovaniemi now sends its last waves into the ether, at least for the time being, I want to let all the inhabitants of our province know that each and everyone of you needs to prepare to move away and to make the necessary preparations to that effect."

Nyholm finished, and then there was nothing but silence. The adults looked at each other. The farmer's wife was crying.

Maj broke the silence and whispered to Nunni, "Why don't we just go home then?"

Nunni looked at her and said quietly, "It may not be possible. Not just yet."

ɷ

Nyholm's radio address electrified the generally imperturbable people of these northern lands. Before all this, when our neighbors in Ylitornio came to visit, the adults would drink their coffee in companionable silence interrupted by sparse comments about the weather. It was as if the wide open spaces of Lapland, the endless summer light and the deep darkness of the arctic

night—the *kaamos*—had provided its inhabitants with a different sense of their place in the greater scheme of things: in the midst of all this natural grandeur, what could be so important to talk about?

The evacuation order changed everything. From farmstead to farmstead, from village to village and town to town, officials on foot, on bikes, and in the few available cars fanned out to spread the word: pack your essentials, food for a day or two, and get going. Now people started talking. Even my friends were wondering: how was this possible? Do we really have to leave our homes and our beloved Lapland, maybe forever? Between sips of coffee, the farmer mumbled: Who will take over? The Germans? The Russians? What will happen to us?

In the evenings, I could hear Nunni and the farmer talking: how was this mass of humanity going to be moved? Lapland's pockmarked dirt roads stretched for hundreds of kilometers across open woodland and fells, and communities were few and far between. The arctic autumn had arrived with its cold winds, and days were getting short. In all of Finnish Lapland, there were fewer than two hundred cars, and the horses that remained in the province—most of them had been taken by the army— were still out on summer pasture somewhere in the forests. It would take days to locate them. The retreating Germans were using the one available railroad.

All of this meant that many people simply had to walk, driving their cattle and livestock before them, to one of the ten designated crossings of the Tornio River. As we bided our time in Ylitornio, we continued watching as these sorry caravans from the eastern parts of Lapland were passing by. "We are so lucky to be so close to the river," Nunni reminded us. "Imagine, having to walk for two weeks, or three, with your cows all the way from northern Lapland."

As always in wartime, the walkers were mostly women, children, and the elderly. Among them were people from isolated

farmsteads at the end of some road who had never seen a train, and who encountered electricity and plumbing for the first time. Many of the cattle-drivers were children.

We heard rumors that the mass evacuations had started in northern Lapland. The people of Inari and Utsjoki far in the north—everyone except the officials—were moved south towards Ivalo and were joined there by the Petsamo evacuees. In these early stages, the Germans helped transport people with trucks and cars whenever available. After all, they believed that the Finns were fleeing their mutual enemy, the Russians. To the common German soldier, it seemed inconceivable at this point that the Finns would turn against them. Had they not lived for three years harmoniously in Lapland?

The dearth of vehicles to transport the evacuees was a big problem. Often, people had to wait by the roadside in the gathering darkness for hours on end for someone to pick them up. People who had brought along more than their barest essentials were told by unyielding truck drivers: the extra stuff stays behind.

In Ivalo, the field kitchens were steaming day and night as thousands of people arrived in town from the north. After a night or two, they moved on, toward Sodankylä, and eventually, just like Lapland's two mighty rivers, the Kemijoki and the Ounasjoki, the streams of humanity converged on the capital of Finnish Lapland, Rovaniemi.

To make matters worse, there was another migration going on at the same time. Karelian refugees, 400,000 of them, were fleeing into Finland away from the fierce fighting in the southeast. They too would have to be resettled, now for the second time.

&

"My dear," my mother wrote on September 20, "it's foggy again today. The island in the middle of the river looms like a dim

shadow. I can hear trucks like ghosts passing on the road. They are building a pontoon bridge to Sweden nearby at Nuotionranta, the Swedes are meeting them on the other side. A barge just went by. It can take 30 cows at one time."

Aunt Biggi had left for Helsinki to join Uncle Bert. She was especially worried about him because he was originally German. How would he be treated now that we were perhaps going to fight the Germans? "I have packed everything," Nunni wrote to Lale, "but no order to depart yet. I still have two empty boxes into which I can put some last-minute things. A couple of days ago a caravan of 280 cows and people from Rovaniemi passed by here on the road—pitiful to see. We're so lucky to be so close to the river. Well, let's see how this war situation develops. Let's hope there won't be too much destruction. The Germans just burned down their barracks here. This poor country! At least you and I are still able to communicate this way, after all, it's these small notes and letters that help me cope with it all.

"But of course, we are now isolated here, and on 'the enemy side.' Wild rumors are circulating, courtesy of the German radio station. But here we have no idea what's going on. I feel like I'm in a black bag. Where is our border now, and what are the Germans still going to do? Rumor has it that the Germans have placed explosives under some bridges nearby. But we can't be sure about anything. But don't worry, if the situation heats up, I'll cross the river with the kids, our things can stay behind in some barn."

As Nunni was packing, I was watching my sister. I had heard about a woman in town who had decided to leave with the German troops because her boyfriend was one of them. Would the soldier my sister had met at the movie come and take my sister with him?

I watched, but it didn't look like she was packing to leave for Germany. And there had been no more talk about the young man since that night. But I was still a little worried. What if they

had locked eyes, just like that Russian soldier in my Grandma Nanny's story?

The wild rumors my mother referred to originated with the German-operated radio station, the Soldatensender Lappland. It claimed that Mannerheim had fled to England and that Ryti was the President once again. Finnish military leaders, the station announced, supported the Germans, and the Russians, they said, were threatening to make Lapland into a new Communist state or annex the whole area into the Soviet Union.

There was no longer a Finnish radio station in Lapland that could squelch any rumors. My mother was not the only one who felt she was in a "black bag."

My father warned: "Don't believe the Lapplandsender. Just German propaganda. Is your radio still working? Try to get Radio Sweden."

No such luck. Our radio was silent.

❧

At the end of September our farmer and his wife gathered all the furniture in their living room and ferried it halfway across the river to an island, where they hid it in a barn. Refugees continued passing by, and I made it my business to sit by the window and count the skinny cows as they lumbered by on the wet dirt roads, their bones showing under their mud-stained hides. Nunni, Maj, and I gathered in our room and wrote to Papi for his birthday on October 1. I drew a bowlful of blueberries and printed: "Hope you get some of these. Kisses." My sister said, "Papi, dear 46-year-old, it's okay here, but PLEASE let me come home 'cause I want to go to school, you don't want an uneducated daughter who doesn't know what 2+2 is, do you? I'll even bike home if I have to!"

So far, there had been no hostilities between the Finns and the Germans. In the evenings, as we waited with our suitcases for the order to leave, the adults were cautiously optimistic.

Maybe there really would be an orderly German retreat? Maybe there wouldn't be any fighting after all? Maybe the Finns and the Germans would indeed have the "pretend war" that my mother had wished for, and we would be able to return home?

Lapland Burns

WE WERE PACKED and ready to go. Normal life in Lapland had ground to a halt. Schools were closed. Like pawns in a chess game, everyone waited while the Germans and the Finns contemplated their next move.

The Germans continued their preparations for departure. Their telephone exchange closed, and so did their movie theater. The soldiers packed up all their materiel and readied themselves for the road. I continued watching Maj, thinking about that Hansi, and worrying whenever she biked into town to see if any mail had still gotten through.

One afternoon, she returned from the post with a letter addressed to her. She was breathless, and she had been crying. "Where is Mother?" It can't be, I said to myself. Dear God, it can't be. "Is it about Papi?" I was able to whisper.

"It's from Hecko. It's about our classmate. Anita. Her father was killed. Three days before the fighting with the Russians stopped. In Karelia."

"Oh dear," my mother sighed. "Only three days. I will write to Anita's mother. And please ask Hecko to give my best to Sargit when you write."

Hecko's mother, Sargit, who lived upstairs from us in our apartment building in Helsinki, was a beautiful and elegantly

dressed woman with large, sad, hazel eyes. I could always tell if she had been in the elevator recently by the whiff of perfume that lingered on. Her handsome second husband, Hecko's step-father, was killed in action. Sargit subsequently took on danger-ous assignments as a war correspondent, sometimes at the front lines, and then worked at the Finnish military headquarters in Mikkeli. After the war, she became Mannerheim's private secre-tary and accompanied him to Switzerland, where he lived out his final ailing years, writing his memoirs. When she returned to Finland after Mannerheim's death, she brought with her a half-finished bottle of the Field Marshal's favorite brandy. On one occasion, she sat down with Hecko and Maj and offered them each a solemn sip of that brandy in a tiny glass.

<p style="text-align:center">༃</p>

There was to be no "pretend war." Despite top-secret negotia-tions in Rovaniemi with the Germans about an orderly retreat, the Finnish military command realized that it faced a stark choice: either do what the Russians wanted and fight the Ger-mans, or risk an open, potentially disastrous conflict with the Soviet Union. On September 20, the Soviet leading newspaper *Pravda* published an ominous article with a warning to Finland: "The main question is the immediate fulfillment of the peace conditions that the Allies have presented to Finland. A week has already passed since the government of Finland should have started to disarm the Nazi forces in order to deliver them as prisoners of war to the Soviet Union, but up to this point, not a single Nazi soldier in Finland has been disarmed or extradited."

As the September darkness deepened and the roads got muddier and the icy winds whistled day and night, the whole population of Finnish Lapland was on the move along the wind-ing roads: the refugees with their cattle trudging south and west, columns of heavily loaded German trucks going north and west, followed by army units on foot, some of whom would end up

walking close to 1,000 miles to the Norwegian border. The Finnish army was following north on their heels—and the Soviets on their side of the border were getting ready to pounce westward for the fight with the Germans over the Petsamo nickel mines.

On September 28, while we were still biding our time on the farm, the first real battle took place between the Germans and the Finns. We didn't even know it was happening. The local radio had stopped, the German radio was unreliable, and we couldn't get Radio Sweden very clearly. And no mail was getting through.

But that fighting, in Pudasjärvi, was not enough to satisfy the Russians on the Control Commission. On September 30, the Soviets once again demanded more decisive action from the Finns. They wanted a real war, with real prisoners of war, and real results. Well aware that further inaction would jeopardize Finland's independence, headquarters hastily drew up a battle plan.

General Hjalmar Siilasvuo, commander of the Lapland forces, was actually one step ahead of them with an audacious plan of attack. In his opinion, the Finnish troops were moving north much too slowly, and the heavy materiel they needed was lagging behind since the Germans were destroying bridges and roads as they retreated—not at this point for fear of the Finns, but to impede the Russians.

Without informing headquarters, Siilasvuo quickly drew up a plan to move troops into Lapland by sea, and to launch a surprise attack on the Germans at Tornio, a town right at the northern end of the Gulf of Bothnia linked by a bridge to the Swedish town of Haparanda. Finnish military headquarters got wind of the plan, but at that point, Mannerheim could not see how he could issue a counter order without appearing to the Russians as if he were temporizing.

"If I forbid this, it's going to be catastrophic for the whole

country," he said. At that point, the ships loaded with Finnish troops were already steaming north toward Tornio.

It was a huge gamble for Siilasvuo. He did everything he could to make those ships look like civilian transports. Trojan horse fashion, the troops were kept under deck. The men had no idea where they were going, nor what their mission entailed.

The weather was stormy, and the plan was delayed for one day due to gale-force winds. But on October 1, it cleared enough and the ships were under way. Not a single military support ship accompanied them. That would have been a dead give-away for the Germans. At the military airport in Kemi, which the ships had to pass on their way to Tornio, sat over twenty German Stuka bombers ready to take off. Had the Germans known the true nature of the ships steaming north, the Stukas could have sunk the ships in no time. But just as they were about to pass Kemi, a powerful squall with heavy rain obscured them from view.

The troops landed in Tornio's harbor, Röyttä. It was a tense moment. The plan had been put into action under such secrecy that even some of the commanders did not know where they were going until they were well under way. The code name for the operation, Äyräpää, was chosen because no German could possibly pronounce it correctly. General Siilasvuo had visited the leading ship before its departure from Oulu and had told the commander of the troops, Lieutenant Colonel Wolf H. Halsti, that this operation simply had to succeed. There was no returning to Oulu until these troops had landed and were fighting the Germans. And Mannerheim, from his headquarters, had stressed, once again, that the future of the country hinged on the success of this operation.

No wonder then that the commander, as they were docking in Röyttä, made a lighthearted suggestion to his men in order to ease the tension on the bridge. "Let's send a telegram, boys: 'To General Eisenhower, France. I, too, have landed. With friendly greetings, Halsti.'"

The Germans in Tornio, still under the impression that they were operating under the rules of a "pretend war," were taken completely by surprise. Some of them had been going around the town apologizing to the local population that they now had to carry rifles. But even before the troops landed in Röyttä, the Germans had been attacked by a small contingent of Finnish soldiers. Once the truth dawned on them that their former brothers-in-arms had become their enemy, they offered stiff resistance, and the Stukas in Kemi joined the fight. In freezing rain and sleet, battles broke out all over town, raging the first day until it was pitch dark. People on the Swedish side in nearby Haparanda could see rockets in the sky, fires from cannon muzzles, and houses in flames. In eerie contrast, the neon lights and lit shop windows of Haparanda twinkled in peaceful Sweden.

By the end of the day, the outcome was still very much in the balance. One Finnish regiment halted near a railroad depot, where they soon discovered a sizeable cache of German wine and brandy. As night closed in on them, the Finnish soldiers— many of them with a tough summer of fighting the Russians in southeastern Finland behind them—set about drinking it up. As soon as their commanding officers realized what was happening, they tried their best to stop it. Lining up his tottering men, commanding officer Pajari went from one soldier to the next and ordered them to exhale. Following him was a captain with a Swiss army knife. Alcohol on the breath, and the military insignia came off the uniform. But it was too late: the next day, those troops were incapable of action.

Yet, after continued intense fighting and after having been refused safe passage out of the city, the Germans started their withdrawal towards the north.

After the battle of Tornio, a group of foreign war correspondents wanted to know how the Finnish commander Lieutenant Colonel Halsti had felt about fighting his former brothers-in-arms. His short answer: "My commanders who are in charge

of my country's existence haven't asked me about my possible feelings."

The furious German general Rendulic issued a communiqué denouncing the Finns for their "base and dishonorable action." His order to his retreating troops was simple: destroy Lapland. From that point on, the leaping flames from burning houses and cowsheds, saunas and barns and whole villages and towns all over Lapland marked the German retreat.

And we in Ylitornio were now directly in the path of this embittered and vengeful German army, heading toward us on the way to Rovaniemi.

&

The news of the fighting in Tornio spread rapidly north along the river valley. "It's started!" shouted our farmer, who had hurried home on his bike after hearing the news in town. "The Finns have landed in Tornio, and are fighting the Germans!"

The news of the fighting initially satisfied the Russians on the Control Commission: the Finns were finally taking action. After Tornio, fighting broke out in several other places in southern Lapland, the Germans fighting a rear guard action as they withdrew toward Rovaniemi with the Finns on their heels. For tactical reasons, the Germans needed to hold on to the town for a few more days until they could begin their retreat toward Norway.

&

The German Twentieth Mountain Army had been headquartered in Rovaniemi. It was a logical choice: located at the confluence of two of Finnish Lapland's longest rivers, the Kemijoki and the Ounasjoki, Rovaniemi was the capital of the province. This gateway to Finnish Lapland was a frontier town and a trading center where lumberjacks would gather to drink and relax after their months of living in logging camps in the deep

forests. Its winter fair, famous all over the region, drew traders from far and wide. On a lively trading day in Rovaniemi, with strong-man shows, merry-go-rounds, market photographers, and quacks selling wonder drugs, you could see Tartars from the east mingling with fur traders from Canada's Hudson Bay Company. When gold was discovered in Lapland in the early 1800s, Rovaniemi turned into a real gold rush town. Gold diggers flocked in from all over the world, liquor flowed freely, and fortunes were made and lost.

Starting in 1941, the German influx had created a second boom in Rovaniemi. Almost every other person in Rovaniemi was German, and there was a great need for local labor and know-how. Whole barrack towns had to be built to house the German military. They established their own military hospital. There was a German officers' club, a German bakery, a bookshop, and a library. They had their own theater, their own newspaper, and their own radio station. They constructed an airfield, and they shipped lumber to sawmills. They painted their barracks and houses with camouflage colors to confuse the Russian planes. They built new roads and improved existing ones. To do all this and much more they needed local labor, and the Germans paid well—sometimes double the wages compared to the rest of the country. Despite the fact that German alcohol made Rovaniemi into the crime capital of Finland, the local population had never had it so good.

And now, it had all come to an end.

At this point, the fate of Lapland's capital hung in the balance. Here was a chance for the Finns to surround the German troops in Rovaniemi and deliver the prisoners of war the Russians so hotly desired. The streams of refugees had moved on. But the Finns did not advance fast enough. By the time they got close, the Germans had begun, with typical thoroughness, to make preparations for blowing up the town.

They started by blowing up their own depots and barracks as

early as October 7, and moved on a few days later to systemati-
cally burn most of the buildings in the town. From the slopes
of the hills surrounding Rovaniemi, Finnish officials watched in
horror as explosions and fires reduced the capital of Lapland to
ashes. For five days, the arctic night was as light as day. The last
building to be set on fire, just before the Germans withdrew,
was the local church. By the time the Finnish troops got there,
on October 16, 1944, what had been the center of Lapland was
a smoldering, heavily mined pile of rubble with only a dozen
buildings left standing.

<p style="text-align:center">∾</p>

While Rovaniemi was burning, the battle over Petsamo, three
hundred miles north of the Arctic Circle at the edge of the Arctic
Ocean, was raging. It pitched 100,000 well-equipped Russians
with superior air power against some 56,000 German troops
with no experience of the devastating firepower the Russians
now employed. During 150 minutes, one hundred thousand
grenades rained down on the German positions. Casualties were
heavy on both sides as the Germans—who for some time had
been trying feverishly to evacuate their materiel from Petsamo
by land and by sea—beat a hasty retreat into northern Norway
followed by Russian and Finnish troops—a scenario unthink-
able only a few months before. Before retreating, however, the
German troops reduced Petsamo to rubble, showing a glimpse
of what was in store for the rest of Lapland. As a farewell gesture,
they left some 200,000 bottles of Champagne by the roadside
as a trap for the Russian soldiers whose fondness for alcohol
was well known. Whether this presented the Russian command-
ers with the same problem the Finnish commanders had had
in Tornio, we don't know. But most of Rendulic's troops, and
30,000 tons of supplies, got away.

<p style="text-align:center">∾</p>

On October 3, there was still no evacuation order for us in Yli-
tornio, though everyone knew it was imminent. The Germans
were rapidly approaching. Nunni decided to take matters into
her own hands. "I'm going to take you across the river," Nunni
announced to us in a calm voice as she packed the last of our
belongings. "We're going to row over to Sweden."

Our farmer had a large wooden rowboat down by the river.
We all climbed in and I sat down next to Riikka. The farmer
grabbed one pair of oars, my mother another. I was looking
back at the farmhouse as it receded during the half-hour it took
us to cross with our heavy load. Riikka was crying and it startled
me; I had never seen her cry before. My sister and my cousin
both looked somber. No one spoke a word. I worried about all
the animals we had to leave behind. I trusted Nunni would take
us somewhere safe. She always had. But the new foal, the cows,
the horse Erkki?

The oarlocks creaked as Nunni and the farmer dipped their
oars in unison into the gray water. I turned around and looked
ahead. I could make out a barn and a few houses on the Swedish
side. So far, no sign of the land of chocolate and oranges, but
as the rowboat touched the shore, I saw Nunni and the farmer
smile at each other, in relief.

Nunni and the farmer's family were taking a risk. We crossed
into Sweden unofficially, without passports or visas—an act that
could have gotten us shot on Rendulic's orders. But she was
counting on the help of some of Lale's contacts in northern Swe-
den, who had written to him offering help. This was not the
time to worry about papers.

There was a small village by the name of Alkullen on the
other side. It was swarming with refugees like us, all looking
for places to spend the night. Nunni was able to rent, from a
friendly Swedish couple, a small attic room that we shared with
twenty-five strangers, while we stored our boxes and luggage in
a barn. Most of us slept on the attic floor.

A small note to my father from Nunni, handwritten in pencil with miniscule letters, gives a hint of what these days must have been like for her. Once on the Swedish side, she came down with a severe toothache. Unable to endure the pain any longer, she left us in the attic room and bicycled to a country dentist in a nearby village. Before she let him examine her, she told him she had only a few Swedish crowns and asked him not to do anything expensive. After a look, the dentist gave her an anesthetic and extracted the tooth. When he told her there would be no charge, she broke into tears, went outside and wrote a short note to Lale:

"I've just sat down on some steps. I've had the most horrible toothache since Friday. It was pouring rain when I bicycled here and I had to wait for two hours to be seen. The tooth is extracted now, and my whole mouth is numb. The doctor didn't charge anything—so kind of him. That's all for now, my hands are freezing...."

Stuck into this note was a laconic message from me to Papi: "It's pretty nice here."

℘

Lale in Helsinki had access to news, and he got increasingly worried about what the Russians might do. He knew we had gotten to Sweden safely, and he was trying hard to find a way to send us some money. He also understood that the failure of the Finns to surround and capture the German troops in Rovaniemi and elsewhere angered the Russians. The Finns, they claimed, had possessed a tactical advantage after Tornio and squandered it. Zhdanov sent a litany of complaints to Mannerheim, accusing him of not capturing enough German soldiers, of treating German prisoners of war too leniently, of transporting all the wounded German soldiers in a Tornio field hospital over to Sweden. He ended his letter on an ominous note: "If the government of Finland and its military leaders do not fulfill these

demands, the military command of the Soviet Union will be forced to undertake such actions as it deems necessary."

When Lale read this, he felt a deep sense of alarm. There was only one possible way to interpret the sense of that statement. Independent Finland was running out of time.

こ

Siilasvuo did his best to get ahead of the retiring German army and surround them in western Lapland, but this proved strategically impossible. The difficult terrain, the destroyed roads and bridges, and the miserable fall weather all conspired to let the German troops reach the border and the safety of still-occupied Norway. The last German troops left Finnish Lapland in April 1945. Nonetheless, the Russians didn't make a move.

Behind them, the Germans left a devastated land. More than one third of the dwellings—over 18,000 buildings—in Finnish Lapland were destroyed, and 230 railway bridges and more than 500 ordinary bridges were blown up. Destroyed houses were mined and so were roads; boats on lakes were sunk, fields of grain burned, herds of reindeer slaughtered.

Lapland's inhabitants, now refugees in either southern Finland or Sweden, had only a vague idea of the dimensions of this destruction. There simply was no one left to tell them.

こ

For two more days after we had crossed to Sweden, while Maj, Riikka, and I waited in the attic room in Alkullen, my mother rowed back and forth across the river to Finland. She couldn't leave the farmstead's cows, she explained; she had to cross the river to milk them until she could arrange for them to be ferried over to the Swedish side. I remember looking at her in the rowboat as the sound of the oars faded.

When the official evacuation order for the population of the Tornio River valley arrived several days later, we were already in

safety in Alkullen. But where would we go now? It was clear that the Alkullen attic was no more than a temporary solution. So many people were now living there that we had to eat in shifts since we were running out of dishes. As she had agreed with my father, my mother wrote to one of his forester colleagues, Axel Elgstrand in the town of Luleå. Would it be possible for us to stay with them for a while?

While we waited for an answer, I gathered my three imaginary friends and thought about my real friends in Helsinki. Three of my cousins had been sent to Sweden with the child transports. We didn't know exactly where they were. Two of my friends had escaped with their families to the Finnish countryside. One had stayed in Helsinki. And here I was, in Sweden. So far, there was no sign of the paradise it was supposed to be, with all the oranges and chocolate. I sat down and wrote a poem for my Papi. I wondered what he, in our chilly Helsinki apartment, felt when he read my pathetic little rhyme:

"Goodbye, goodbye, my native land,
Goodbye, goodbye, my Father's hand."

CHAPTER NINE

The Lapp King's Daughter

THE GATES to the Swedish Paradise finally cracked open
when we entered the apartment of my father's Swedish col-
league, Uncle Axel Elgstrand, in the northern town of Luleå.
We left Alkullen in a hurry to catch the train, leaving most of
our possessions behind. But here we were now, my mother, my
sister, my cousin Ulf, Riikka, and I, basking in the seemingly
endless good will of our tall, handsome, and friendly Uncle Axel
and his sister-in-law, Helga, who lived with the Elgstrands. Mrs.
Elgstrand worked in another town and visited only on week-
ends. After our first evening with them, my mother hastened to
write to Lale:

"Dearest love,

"Hope you can imagine how wonderful it was, after these
last days in Alkullen, to come here. We are as well as anyone
can possibly be. Warm water in the evening, we could all take a
bath (we needed it!). Good food with a glass of vermouth. Their
concern for our well-being has no limits. Today, I got breakfast
in bed with all sorts of cakes. Even Riikka, who sleeps in the
guestroom of a family downstairs, was served coffee in bed! And
today we've had a lovely Sunday, walked around Luleå and en-
joyed the peace and quiet and then a glass of Madeira with fruit
and chocolates after dinner!"

Since we had crossed the border on our own, we had avoided the time-consuming chaos of the official crossing stations into Sweden, with their obligatory health inspections and often humiliating delousing saunas and steaming of clothing that thousands of Finnish evacuees entering Sweden had to endure. But it also meant that we, in contrast to them, had no papers. In the eyes of the Swedish authorities, we were stateless persons. Uncle Axel promised to see what he could do to get us visas, or refugee passports. To make this easier, he and my mother set about finding work for her in one of the many Finnish refugee camps in the outskirts of Luleå. My sister volunteered to do her part and write letters for wounded Finnish soldiers who were housed and treated at a nearby school. Uncle Axel was well positioned to help my mother: he had been put in charge of an organization called the Center for Finnish Livestock (Centralen för finska kreatur), whose task it was to house and care for the thousands of cows, horses, and other animals that had arrived in Sweden with the refugees from all over Finnish Lapland. That organization, and her work with the refugees, took all of my mother's time in the next few months. But right now, she was eager to know what Lale in Helsinki was thinking about Finland's political situation. She was desperate to return home. What were our chances? She wanted an honest answer, and my father tried as best as he could to give her one:

"You ask about my plans for you. If only one knew what is best. On the one hand, of course I am longing to have my dear ones with me again here at home, and for life to be normal once more. But who knows what will happen? The whole implementation of the cease-fire agreement is only beginning to take shape, and thus it's impossible to tell how the Russians are going to interpret all the ambiguous points and what fate they have in store for us. There are both optimists and pessimists. Some people think that things will be fine, even though life will be difficult and the standard of living low. Others (my dear brother

Totti among them) think that we Finns, sooner or later, can ex-
pect to share the fate of Estonia at the hands of the same master
who took charge there. So what can I say? You can understand
that there are many questions to ponder and that it isn't easy to
decide anything with regard to you. I'll still think about all this
and talk to some people. In any case, right now, you should try
to work among the refugees and be useful wherever you can."

A few days later, he returned to the same question. No one
could know what might happen. So far, the members of the
Control Commission were behaving themselves, but then again,
they did so in Estonia until repression and deportations started.
Maybe, just maybe, we might be able to live as a "free" country,
albeit tightly controlled by the Russians. Even so, because of the
heavy burden of war reparations, life would be hard and there
would be scarcities of every kind.

"Then there are those who look more pessimistically at ev-
erything," he continued. "They see this as only an interim sit-
uation and think that the Russians, sooner or later, will find
some excuse to occupy the country and then start doing what
Zhdanov did in Estonia 1939–41. But even if those pessimists are
proven right, this situation could still go on for several months,
and the situation right now is relatively tolerable. It could get
really cold this winter in Helsinki, however, and there isn't much
milk (½ glass per person is all you can get in a restaurant), lack
of potatoes too, but I wonder if one can't manage this winter, if
one only knew that this will pass and that nothing worse awaits
us further down the line.

"And that, my dearest, is the whole point! Right now, my
feeling is that you could very well come home and be relatively
fine, but if the situation should take a turn for the worse, there
is no way to know whether you could then easily return to Swe-
den. Please talk to Axel and see what he thinks.

"Of course, if you really want to take the risk and come, I
won't prevent you. But I wish to God that it won't prove to be
the wrong step!"

My mother could read between the lines. Much as she was longing to leave Luleå and take us home, she decided to stay—for now. Soon, she had found a job as the supervisor of a small refugee camp just outside the town, where her fluency in both Finnish and Swedish were real assets, and where her work on behalf of the refugees would be appreciated by both refugees and Swedish officials alike. So, for the next few months, she lived in a small, sparsely furnished room close to the church housing the refugees. She tried to come and see us whenever she could. Because of the infectious diseases among the refugees, it was not possible for us to visit her.

∾

"Coming to Sweden has been like turning on the lights," Nunni wrote to Lale. "We can finally know what's happening in the world after the black bag of Lapland."

The world was entering the last, cataclysmic phase of World War II, and now we were able to follow events in the Swedish newspapers and over the radio. December 1944 and January 1945, we read about the gigantic Battle of the Bulge in the Ardennes (in Belgium, Luxembourg, and Germany), where American and British forces engaged the Nazi army in one of the bloodiest battles of the whole war. When it was over, the U.S. had lost 19,000 men and 81,000 were wounded. The Germans reported 100,000 killed, wounded, or captured—the vast majority of them only fifteen or sixteen years old. In mid-October of 1944 we followed the intense battle for the island of Leyte in the Philippines between the Japanese and the Americans, preparing their way to take Japan. My sister Maj thought General MacArthur was very handsome and pinned a newspaper clipping with his photo on her wall.

My drawing sessions at the Elgstrand's kitchen table turned to the production of a four-page occasional newspaper called *Stina's World News*. It had five subscribers (my own family members and the Elgstrands) and it focused on international stories.

Since I was spending much time by myself, my imaginary play-mates returned. Most articles in the World News were signed either by Gutter, Better, or Anschovinchen Bonscheli.

ço

My mother had made the right decision when she decided we would remain in Sweden. Lale said that the food situation in Helsinki was dire. Potatoes, the staple food, had to be substi-tuted by rutabagas, and even those had often been damaged by freezing. And now the Finns, forced by the Russians, had started to arrest the "war criminals" on the Russians' official list of sixty-óne names. One of the first to be arrested was General Palojärvi, on the steps of the church where he had just gotten married. One of my father's forester friends was arrested, too, for possess-ing weapons. He was a hunter. My mother wailed: "You were in eastern Karelia—will you now be arrested too?"

We were enjoying the plentiful food, the warm water, and the heated apartment in Luleå. Riikka and I slept with the downstairs family, and Maj made her bed at night in the Elg-strand's living room. But the warm glow of our first welcome was already beginning to fade. Much as we tried to be polite and inconspicuous, Uncle Axel's sister-in-law Helga, who ran the household since Mrs. Elgstrand worked in another town, gave us the distinct feeling that we were in the way. "Sweden will soon turn into a poorhouse with all these refugees," she would mutter. As she presided over the dinner table, we noticed she was checking the amount of food we put on our plates. Uncle Axel himself was always warm and friendly but absorbed with the enormous task of organizing the care of the Finnish cows and horses. Maj spent her time babysitting children and assist-ing hospitalized soldiers with their letters. I was left to my own resources since Riikka had taken a job with another family. Most days, I spent my time drawing and writing at the kitchen table. Going outside was not an option, since my only pair of shoes had worn out.

Nunni was to have stayed with us, but after a few days at her job in the refugee camp, she called and said she was not allowed to leave. There was a case of diphtheria in the camp, and the whole place was quarantined. We did not see her for three weeks.

At this point, we faced a real financial crisis. Because of currency restrictions, there was no way for my father to send us money. We had to manage on my mother's meager salary from the refugee camp. Nunni would never have accepted any monetary help from anyone in Sweden, even if it had been offered. With whatever was left over from her savings, she bought food for Papi and sent it to Helsinki.

"What worries me most is how you'll manage there with the scarcity of food. Last week I sent you a package with: ¼ kilo coffee, 1 kilo sugar, two soaps, a toothbrush, toothpaste, some candles, ½ kilo rice, 100 gram raisins, 1 kilo butter. Do you eat at home? What can you get? And what about your laundry? Please ask the apartment manager's wife to do some laundry for you, so you won't go without warm clothes. Shall I try to buy you some long johns from here? Who mends your clothes? I have so much work here—will have for a long time to come—where are all these poor refugees going to end up, with their homes burned down? We have a guard here at night—it's good to know someone is keeping an eye on the wood-burning stove. Now I've finished both the scabies and the lice treatments, yesterday I washed little six-year-old Anneli's head. She follows me everywhere. A young boy of 12 is sometimes crying for his mother, I try to appeal to his grown-up masculine side, and then he blinks his eyes, and swallows his tears. Something's happening all the time, the telephone rings constantly and we have two, three meetings every day. Most people are good, but some complain and then I just try to listen while I think about something else."

One of the most difficult things for Nunni was to deal with the bureaucracy that quickly grew up around the refugee effort. "Everything gets endlessly complicated here because of all kinds

of directives, and as a result no one dares to do anything on their own initiative, you always have to have a fallback position and be able to rely on this or that paragraph and this or that directive of a certain date. Because of this, even the simplest thing takes forever to get done. Almost everyone recognizes this and people are groaning under directives upon directives. Excessive organization everywhere!

"Dear," she ended the letter, "we're fine here, but I'm longing for you. There is nowhere in the whole world I'd rather be than with my head against your shoulder and your good hand in mine. May God grant that we'll soon be together again. Until then I'll try to be brave and in a good mood. You know, sometimes in the evenings I feel your presence so strongly—it astonishes me. Our anniversary is coming up, and on that day our thoughts will be with each other—let's pray that we'll never again have to be separated on that day. Dearest good husband and friend! Sometimes I feel as if I'm walking around in a fog. We're fine, but I worry so about our country."

Lale in Helsinki did not hide his worries about the country's future either. "The Communist Party has again become an officially registered party, and yesterday they had a big meeting in the convention center and are starting to campaign for the parliamentary elections. So—things don't look too bright, except in the streets where there is now illumination like in peacetime. No more blackouts—but people still keep their curtains drawn to preserve the heat. Today, they are "heating" our apartment and it's 15° C inside! And my dear, don't even think about coming here without the children, because a situation could arise when it might not be easy for you to go west again."

My sister was more homesick than ever. "I want an airplane for Christmas," she wrote to her friend Hecko, who was back in Helsinki, "because then I could fly home to Finland. I guess you see Papi sometimes? Has he lost a lot of weight? Do you have any food, potatoes and such? Let's see if I get any Christmas presents this year. Mami doesn't earn too much, you know, but

that doesn't matter. I don't feel like celebrating Christmas at all, I'm so homesick."

But one day, Uncle Axel asked my sister for help. The Swedish Crown Prince Gustav Adolf—the future King Gustav VI Adolf of Sweden—and Crown Princess Louise were coming to northern Sweden to tour the Finnish refugee camps. They had also expressed an interest in seeing some of the barracks where the refugees' cattle were kept. That was Uncle Axel's domain, and now he needed an interpreter. My sister was the perfect person: bilingual and presentable. Needless to say, she readily consented and a few days later, after many sessions of practicing curtsies—was this too low, not low enough?—Uncle Axel and Maj were off to meet the Royals.

"Oh my God," was all she could say after she returned. "Oh my God." It turned out that just as the Crown Princess was asking her a question in one of the narrow temporary cowsheds, a cow had lifted its tail and sprayed the unsuspecting Crown Princess's fur coat with a shower of dung.

"Luckily," my sister said, "the fur was the same color as the cow shit. But I almost died. You should have seen the attendants trying to wipe it all up with their white handkerchiefs."

I spent much of the next day trying to draw a picture of the cow spraying the Crown Princess. At one point, Aunt Helga passed by and asked what I was drawing.

"A cow shitting on a Princess."

Aunt Helga, who was a staunch royalist, was not amused.

∽

In early November, our living situation with the Elgstrands became critical. "The more I get to know Helga, the less I like her," my mother confessed to Lale. "She is so cold and 'correct'—and her polish is skin deep. My soul shivers in her presence." One day, Helga forbade me to draw at the kitchen table, and the final straw for my mother was when Riikka confessed to her that Maj and I were sometimes going hungry during the day. Nunni

arranged for Maj to move in with another family who had a
daughter her age, for the ostensible reason that she needed com-
pany, and she was also allowed to attend the daughter's school.
Riikka's job with the Swedish family came to an end, too. Nunni
realized that the family she worked for was taking advantage
of her with their endless parties and dinner dishes, and paying
her very little. She found a new family for the two of us, the
Bergströms, who treated us very well. I was enrolled in the local
elementary school. Our situation was becoming stabilized, al-
though Maj still pointed out in a letter to Papi that "food is great
here, poor you who don't even get potatoes, but I'd a thousand
times rather be there at home and eat swine food than here...."

Though she enjoyed feeling she was needed, Nunni was
drowning in work at the refugee camp. "I now have forty people
here and everyone's papers have to be processed, their addresses
have to be double-checked, appeals written, clothes procured
and distributed, beds arranged, and then I have to oversee
housecleaning, meal times, dishwashing, cleaning of the back
yard and the outhouse, run their small errands, go to the hospi-
tal and interpret for them, see to it that the children have protec-
tive wax cloths under their sheets, distribute snacks and apples,
try to find something for everyone to do, listen to their stories,
be positive and helpful in each and every case. Then there are
conferences with doctors, getting rid of head lice, buying and
selling of tobacco, etc. And now I have a salary of five crowns a
day! Despite all of this, I can't imagine looking for other work—
who else would then take care of these poor people? Maybe fate
has put me here? If I had time, I could take some extra physio-
therapy work, or typing. As soon as I have time, I'll send you a
package of food. And yes, I'll get you some shoelaces."

Lale was very busy in Helsinki, as the secretary of a newly
appointed commission that was to advise the Department of
the Interior on how to restore the Finnish forestry industry. He
shared our Helsinki apartment with Grandma Nanny and his

brother Totti, whose apartment had its windows blown out in a bombing raid. Lale adds: "It rained all day today, very strong winds too. At least five mines drifted onto shoals just outside the shore and exploded—our whole building shook!"

ຕ∂

Maj was initially happy that she would go to school in Luleå. She did well, and earned praise for her Swedish compositions— even her composition teacher was initially puzzled by how well she spoke the language. Her art teacher thought she was very gifted and submitted one of her drawings to a show. But there was a problem: her math teacher was a real terror. Maj sat down and wrote an indignant letter to Lale: "You know, our class has a math teacher who is a hippopotamus and a boxer! To a large extent it's his fault that so many of us don't pass math—almost no one has received a passing grade. I would do SO much better if you were here to explain things to me! The other class has a different math teacher and they are really learning something. Our teacher, whose name by the way is Hellmich, doesn't know how to teach at all. He hit a boy so hard that his ear started bleeding and he hit another boy straight in the face and floored him! He hasn't hit me yet, but if he does, I will hit him back—it's self-defense! He hits at least five or six pupils every lesson. True, teachers are not allowed to hit their students anymore, right? I'm SO mad at him!"

I heard about the cruel math teacher and now I was worried since I was to start school as well. One morning in November, Riikka left me by the gate of the Luleå Elementary School. "Remember, it's second grade, and be sure to curtsy when you shake hands with the teacher and tell her your name." Bewildered and shy, I found my way into the four-story red brick building. What a difference from the one-room schoolhouse in Ylitornio! I had never seen so many children in one place.

My tenure in second grade was short. The teacher decided

to test my reading skills, and asked me to step up in front of the class. Then she gave me a book, opened it to a particular page, and said: "Read."

The letters danced around on the page. I saw Joseph, and Mary, but they refused to sit still in a sentence. There was a deep silence in the class, and some giggles, and then the teacher asked me to sit down. After class, she called me and said: "I think it would be best if you start in first grade."

First grade was a big improvement. Initially, my classmates also couldn't understand how it was that I could speak such good Swedish. I was a Finnish refugee, wasn't I? I briefly considered passing myself off as a linguistic genius before telling them that there were Swedish-speaking people living in Finland. "But you speak a funny Swedish," they would say. "You sing. It's cute. Say something."

And I would say, it's you who sing. And you use funny words.

There were colorful pictures on the first grade classroom wall, and I was placed next to a friendly girl with long braids whose name was Brita. On the second day, however, disaster struck. I needed to go to the bathroom, very badly, but didn't dare to ask. The minutes dragged on, and I became desperate. What does one do in this situation? Maybe no one would notice? I decided to chance it, and with enormous relief I felt a warm trickle running down my leg.

But someone had noticed. Brita looked at me, looked at the pool gathering on the floor, and after class was over, she said: "I'll make you a deal. I won't tell anyone if you come with me to Sunday school, every Sunday."

Nunni was pleased but somewhat surprised about my new-found enthusiasm for the Lutheran Sunday school. My first time there, I was given an attendance sheet in the form of a glossy picture of a field with two children picking flowers. There were big white circles where the flowers were supposed to be.

And every Sunday, we were given one marigold to paste into one of the empty circles. I counted them, and promised myself that we would be back in Finland long before flowers covered those circles.

Life in Sweden improved. The Bergströms were very nice to me and allowed me to draw whenever and wherever I liked. There was plenty of food and milk for both Riikka and me. The quarantine at the refugee camp was over, and Nunni came for frequent visits. Maj and her friend Anna came too, and would take me out for walks around Luleå. Here was the Sweden I had heard about: neon lights, illuminated shop windows with everything you could imagine. Shoes, clothes, candy. Ladies strolling around in fur coats and fancy hats.

One day, Mrs. Bergström held up a long, slightly curved yellow object right in front of my face.

"Do you know what this is, my dear?"

I had heard of bananas, but the idea of actually having one completely overwhelmed me. How could I possibly accept it?

Mrs. Bergström repeated the question. Deeply embarrassed, I had to think of something fast. A familiar shape, but not as fancy, came to mind.

"It's a cucumber," I tried.

"Oh dear me. Seven years old, and never seen a banana. Here—let me show you how to peel it."

The next day, I drew a picture of a banana for Papi. Next to it, there is a picture of a piggy bank, and a twenty-five-öre coin. The caption: "I am rich. Are you coming here for Christmas? I have made three presents for you." I also included my wish list for Christmas. On that list of items: A pencil-sharpener, a pair of stockings, a small mirror and, finally, "a suitcase for evacuation."

☙

In Helsinki, Papi was feeling the pressure of the Control Com-

mission. He had been working overtime at the Ministry of the Interior to provide the Russians with statistical information on the Finnish forest industry. They had five days in which to produce the document and have it translated into Russian, and they had been working day and night. If he thought this harassment was a small Christmas present from the Russians, he would not have dared to say so in his letter to my mother. But he added: "The annual Forestry meetings were all right, people's spirits not too high though. Those who had reserved their rooms at the Karelia Hotel all had to leave—the Control Commission suddenly took over the whole hotel. In addition, they even requisitioned some private apartments in the adjacent building—those people too had to clear out just as fast. Where are they to go with all their furniture and belongings?

"Well, this won't be such a happy Christmas for us, but we'll have to take comfort in the fact that this too shall pass, and that we are well and not starving."

<p align="center">❧</p>

We were going to spend Christmas with the Elgstrands, and they tried their best to help us have a real holiday away from home. We decorated our tree with candles and sparklers. Food was plentiful: a big baked ham, pickled herrings, beet salad. The house smelled of mulled wine and gingerbread. But I missed Lale. For Nunni, his absence and her deep worry about Finland were almost too much to bear, but she never let us know how she felt. Her letter to Lale said it all:

"My dearest,

"It's Christmas morning—I got up at five and went to the Old Church for the early morning Christmas service at six o'clock. Some snow had fallen, the ground was white and small pearls of ice, like tears, were hanging from the frozen branches of the birches. Bells were ringing, and a steady stream of people walked into the illuminated church where two Christmas trees

were shining with bright lights. On the altar stood a seven-armed candelabra and the whole area around it was decorated with pink begonias in huge pots. The church bells were ringing and the mighty psalms echoed up toward the towering vaults of the dome. After the sermon there was singing and music. My heart was overflowing with longing for you and our home, and filled with prayers for all the suffering people in this horrible time; filled also with prayers for help for our dear country—and my tears began to flow, tears that I had kept under control for a long time. I was completely alone among strangers and it felt so good to cry. When the psalm was over, a little girl came and offered me a piece of chocolate! Her mother had probably asked her to do that, and it was a moving and heartfelt gesture of empathy and consolation. It was still dark outside when the service was over, and I wandered around without anywhere in particular to go. I could see candles and illuminated Christmas trees in people's windows, and everybody was hurrying home. In my mind's eye I could see all the burnt-down villages, and the refugee camps here in Sweden filled with homeless people, but my deepest sorrow was for my country, my country that is in deep trouble, and my tears continued to flow and it just felt good. I felt such gratitude that we still have each other, all four of us, and that our home still exists—all the rest we have to leave up to God and trust that everything will turn out well. If we cannot believe that—then we cannot work, and without that, we are doomed. It was already light when I came back here, and I lay down and slept a bit."

<p style="text-align:center">✐</p>

When I returned to school after Christmas break, three classmates met me in the corridor.

"What did you get for Christmas?" they asked.

"A flannel nightgown," I said proudly. Strictly speaking, it was true, but to my great sorrow the nightgown had gotten

lost and probably thrown away with the wrapping papers. "And crayons and paper."

My classmates were not impressed. "I got a bicycle," said one of them. "Red. My dad gave it to me. Where is your dad?"

I was starting to dislike the drift of our conversation. I decided to make a pre-emptive move.

"I don't need a bicycle. My dad is the King of the Lapps and where we live we have a thousand reindeer and always get pulled everywhere in sleds."

"You're the Lapp King's daughter?" they asked, slowly.

"Yes, and my Dad's been very busy with Christmas and all. He loans some of our reindeer to Santa Claus and his elves."

"I don't believe you. It's a sin to lie."

"I'm not lying. I'll show you a picture tomorrow."

The next day, I brought a picture of me in a Lapp costume that Nunni had taken in Ylitornio.

"Here," I said. "We don't wear crowns in Lapland, like your king. Just hats like these. Except for royal occasions, when we wear black berets."

"Royal occasions?"

I pulled out a newspaper clipping. In it, my sister is standing next to the Crown Prince and Crown Princess of Sweden who are visiting a Finnish refugee camp. She is wearing a black beret.

"This is my sister. She is the Lapp King's other daughter."

There was a long silence.

"Would you like a chocolate?" one of the girls asked.

Things at school got much better after that.

CHAPTER TEN

Do Horses Get Homesick?

THE SMALL refugee camp that my mother headed was only the tip of the refugee iceberg. By the end of November 1944, of the 168,000 Finns that had fled Lapland, close to 56,000 had crossed over to Sweden with their cattle and few belongings. And now, while they waited to see what would happen to their homeland, they had to be housed and fed.

The Swedes had given permission for this stream of humanity and animals to enter their country within the span of a few hours. As the refugees made their arduous journeys toward the border crossing points, the largest humanitarian operation ever attempted in Scandinavia was quickly launched. It was directed from the Royal Civil Defense Department (Kungliga civilförsvarsstyrelsen) in Stockholm.

However neat and simple the directives from Stockholm may have appeared on paper, in reality, the sheer number of people coming into the country often resulted in chaos at the border stations and beyond. Family members had sometimes lost track of each other en route and ended up in different camps. People who were ill were taken directly to hospitals—and that often meant that sick children lost touch with their parents. The lack of interpreters compounded the difficulties when the refugees were met by sanitation teams, had their chests x-rayed, and then

were given a hot sauna while their clothes were being steamed to get rid of lice infestations. Sometimes the crush of refugees at the border points was such that the Swedish authorities forgot modesty in connection with the "lice saunas." My mother received an indignant letter from our Ylitornio farmer's wife who had been made to walk naked with many other refugee women into the sauna between two rows of what she perceived were jeering Swedish soldiers.

Quarantines of two weeks or more were set up for those suspected of diphtheria or tuberculosis. Nunni initially worked in one of these quarantine camps in Luleå. All tests had to be sent to laboratories in Stockholm. Those cleared from the quarantines were then sent on to refugee camps that had been set up in schools, parish buildings, empty houses, specially constructed barracks, and military facilities in over fifty communities in northern Sweden. Eventually, there were some 600 camps, some housing as many as 2,000 refugees, others housing only a dozen. As far as possible, the authorities tried to keep people from the same village or town together in their new "communities," which would often have the same name as the place they had left behind in Lapland. There was a "Little Rovaniemi," a "Little Tornio." As reports started to trickle in from Finland about the extent of destruction in Lapland, people realized that these new "little" communities had many more houses standing in them than the devastated ones they had left behind.

Since most refugees had arrived with nothing more than the clothes on their backs, everything else had to be provided for them. A wide-ranging system of borrowing was set up. These lists of items borrowed, moldering now in the War Archives in Stockholm, offer a glimpse into the material world of the refugees as eloquent in their sparseness as any description: forks, spoons, knives, milk bottles, towels, beds, hammers, saws, nails, axes, and pots and pans had to be found for them, as well as irons, washtubs, bowls, ladles, children's beds, straw mattresses,

and blankets. They needed paper sheets, and paper mattresses, and carbide lamps, lanterns, and flashlights for the long dark nights.

The camp inspectors had a busy time making their rounds of the camps and filing their reports. Just before Christmas, one of them wrote from a camp of 150 people, 100 of them children, housed in the People's House in Lycksele:

"The visit took place around seven o'clock in the evening. Many of the children had been put to bed and were already asleep, fully dressed. They were dirty and pale and made a distressing impression. Some of the children slept covered by blankets they had brought along from Finland while others only had a mattress in their beds. These mattresses were often in such bad condition that only a few shreds of them remained which barely covered the wooden planks of the bed. Since some very small children also used these beds without much supervision, there was a stench of urine around many of these beds. The floors were dirty, and whatever sweeping took place in the evening did not seem to be of much help. It is clear that many of the people who live in this camp do not have very clear ideas about hygiene and this of course makes the work of the camp leaders more difficult. But from the point of view of Swedish society it is of utmost importance that these camps be run in such a fashion that they do not become sources of dangerous epidemics."

Another report in the archives gives us an idea of what the Swedish public health officials had to deal with. "In October of 1944, over one thousand Finnish refugees were housed in the district of Dorotea, thus increasing the district's population by eighteen percent. Since there were few places to house the refugees, the camps became very crowded. And from the very beginning, the evacuees have been plagued by all kinds of illnesses. Influenza, gastrointestinal diseases, diphtheria, scarlet fever, measles, whooping cough, chickenpox, tuberculosis, head lice, lice, scabies and impetigo have been the most common, in

addition to their complications—and then all kinds of chronic diseases."

The writer then goes on to say that two Swedish doctors and their assistants had done a tremendous job trying to keep the health situation in check. Their difficulties were compounded by the fact that it was hard to explain to the evacuees the necessity of quarantines. "These are primitive people," the writer says somewhat condescendingly, "from a place north of the Arctic Circle, and with the egocentricity of primitive people, they cannot understand why people who are not sick have to be kept isolated. That this is done to protect the local Swedish population is something they cannot understand. And the language problem complicates everything.

"The mothers hide their children who have pneumonia rather than be separated from them and have them taken to the hospital," the writer continues in exasperation. "No wonder some children die, since their parents have such vague ideas about what's best for them.

"It has happened that whole groups of evacuees have refused to submit to the diphtheria tests, knowing that the tests would reveal that some were carriers and that this would lead to isolation for a time. We have had to spend a great deal of time in diplomacy or persuasion."

In the same report, the writer describes a child who had tested positive for diphtheria and needed to be taken to a hospital. The mother would have none of it. "She kept circling around the nurse, swearing furiously, and threatening to dump a bucket of dirty water over her. The police and Dr. Nyrup were called in, but to no avail. Finally, there was no other recourse than to call the murderer among the refugees (a man who had been convicted of armed robbery and murder and done 12 years in a Finnish prison). That helped, the Finns had a great deal of respect for him, and he is actually used as an orderly of sorts."

Body lice and head lice were common in the camps. There

was "a new chemical de-lousing powder" that had been used very successfully in countries at war. Its name was DDT, and the authorities in Stockholm recommended its use in the camps to combat lice. It was to be sprinkled liberally on the inside of jackets, sweaters, pants, and socks. Bedding was powdered, and even underwear. Those with head lice had their hair powdered with DDT, a treatment that was to be repeated in two weeks. As the powder was relatively cheap, it was considered a godsend, and no one questioned its possible deleterious effects.

As the camps got better established, the people tried to organize all kinds of activities to pass the time. There were sewing circles for the women, and musical evenings and dances for the teenagers. Itinerant Finnish preachers visited the camps to help keep spirits up. A refugee newspaper was published. Many people in the camps began to appreciate what the Swedes were doing for them. A woman from Pello remembered: "Shame on those who say that we had a bad time in Sweden. I've never had it so good as there. We got food and clothing. We got sugar and even real coffee. They took such good care of us that you couldn't wish for any better."

The Swedes also tried their best to organize day care, kindergartens, and schools for the refugee children. Whole orphanages had been evacuated to Sweden from as far away as Petsamo and continued functioning in their new locations. In a matter of weeks, sixty-five schools for Finnish children had been established. There were few books in Finnish, but the Swedes saw to it that pencils, paper, and other supplies were available. The schools muddled on with many breaks because of various epidemics running through the camps. The worst off were the real Lapp children, the Sámi. Most of them came from the very far north where schools had already been disrupted for years because of the tense situation at the eastern border. Very few teachers were able to teach in the Sámi language, and those children did not understand Finnish.

It was lucky for me that my classmates in the Luleå Elementary school didn't know any of this. To them, I continued to be the Lapp King's daughter, although I struggled as much as they did with the multiplication tables.

<center>ↇ</center>

I was fond of Uncle Axel Elgstrand, and he of me. When he called me his little Princess, as he often did, I used to bow my head and curtsy. Even after we had moved to new families, we would occasionally visit him. My Christmas present to Uncle Axel was a drawing. It showed dogs running, horses sleeping, pigs eating, sheep huddling, cows being milked. The caption: "His troubles."

At the time, I had only a dim idea of what Uncle Axel's work at the Center for Finnish Livestock really entailed. Coming home from the office, he would put on his slippers, pour himself a glass of sherry and entertain me with stories of people looking for this cow or that horse, and shake his head.

"We had a letter today," he said. "A woman is looking for her cow. Says it's got one white ear, and is called Ruusu (Rose). She doesn't sign her name or tell me where she is, just asks me to find her cow."

Sixty years later, I was standing in a cavernous warehouse building in Stockholm that houses the less frequently used materials of the Swedish War Archives. I had come there to try to understand just what Uncle Axel was doing during those months in the fall of 1944 and early 1945. I was given call numbers for boxes stacked all the way to the ceiling, and a tall ladder. The boxes began to speak, with mind-boggling thoroughness.

When the refugees had arrived at the Swedish border, time was of the essence for Uncle Axel. Some of the cows had already been on the roads for several weeks, in inclement weather. Their hooves were bleeding and their milk was beginning to dry up. Fodder had been increasingly hard to come by for the later cara-

vans. Finally, from Kemi on, the cattle could be put on trains and transported to Sweden, some of them on open flatbed cars surrounded by rickety guard rails made from local fences. Of the 50,000 cattle, horses, and other animals making the trek out of Lapland that fall, 30,000 ended up in Sweden as Uncle Axel's "troubles."

Within a matter of days, the Center for Finnish Livestock was up and running. One person was put in charge of procuring the fodder and the hay. Another was responsible for acquiring barracks and finding empty stables and barns to house the horses and the cows in the northern Swedish districts of Norrbotten and Västerbotten. A veterinarian was responsible for the health of the animals, someone else was chosen to inspect the facilities, and yet another person oversaw the finances. The office had to be furnished: desks, chairs, a calculator, rulers—everything, according to the archives, sent from Stockholm and sent back in January of 1946.

Stored in the archives were also registration cards rubber-banded into bunches of fifty. No one had looked at them since 1946, and the rubber bands pulverized in my hands when I touched them. There was one card for each and every animal that had crossed the border, specifying if it was a stallion, a mare, a foal, a bull, a cow, a heifer, a calf, a pig, a lamb, a goat, or a dog. It listed the village or town the animal came from, and the name of its owner. It noted the date when the animal had been repatriated to Finland. All of this bore staggering witness to Uncle Axel's thoroughness.

A stream of directives flowed from the Center as well. Just as the refugees were not supposed to mix with the Swedish population, no Finnish livestock could be housed where there was Swedish livestock. Swedish bulls were not to be used to inseminate Finnish cows, one directive admonished. Another one urged that some of the manure from the barns be spread—for obscure reasons—on airfields.

The person in charge of the barn oversaw all the work related to the cows, from their feeding and their milking to checking that the hay was stored correctly so it wouldn't mold, to reporting any illness to the veterinarian, to directing the milk transports to the dairy. The person responsible for the stables had similar duties, all spelled out in detail. The tails and manes of horses were not to be cut. The horses had to be exercised every day and their hooves shod at regular intervals. By the end of November, when the last of the livestock had crossed the border into Sweden and been housed, and my sister with her black beret and white socks and gloves interpreted in one of the cowsheds for the Crown Prince and Crown Princess, Uncle Axel and his team had put in place an organization that the Swedes could be proud of.

One day when I visited Uncle Axel, I presented him with a new drawing. A horse in a stable is munching his hay and a thought bubble hovers over his head. It says: "Lapland."

"Uncle Axel," I wondered, "do horses get homesick?"

CHAPTER ELEVEN

Thinking Home

UNCLE AXEL, kind as he was, took my question seriously. He knew I was asking about horses, but he also knew I was asking about myself. Was it all right to be having this gnawing ache inside every day? Yes indeed, horses could be homesick, he said. Hadn't I heard how horses that had spent years in the war would start to trot and then finally gallop as they were nearing their old homes? It all proved, said Uncle Axel, that they had been thinking about home the whole time they were away.

"A little bit like people," said Uncle Axel.

"Yes," I said. "I think horses are a little bit like people."

&

Did I ever doubt that we would eventually return home? That some day we would take the reverse train journey, that Papi would be waiting for us at the station in Helsinki, that school would start up again, and I would sit in class next to my friend Poppy, that Anita and I would spend our Saturday afternoons ice-skating on the pond? That Merete and I would again pick wood anemones and lilies of the valley in the forest or play by the small brook that rustled at the back of our school? That the siren on top of our building, Hoarse Freddy, would cease its wail, and that Riikka would find enough meat at the butcher's

to make her juicy Karelian roast with carrots and potatoes when Uncle Totti, his wife, and my cousins came for Sunday dinner? That I would not end up like that girl in my class, skinny and serious Maret, who had fled to Sweden from Estonia with her parents and her brother in an open boat as the Russians moved in? She was never going back, she said.

To prevent such a calamity from happening, I spent a lot of time by myself at the Elgstrands, and later on at the Bergströms, conjuring up the world we had left, as if thinking about it would restore it to us.

Home was the island of Brändö, at that time connected to Helsinki proper by a rickety wooden bridge. The community of Brändö (Kulosaari in Finnish) had been founded in the early 1900s by a group of architects, dreamers, and wealthy men. Their idea was to create a semi-urban utopia, and in those early days, it was. Surrounded by water on all sides, it was an idyllic place, very conscious of its charms, with narrow gravel roads over gentle hills, sprinkled with villas mixed with more modest houses, a yacht club, a tennis club, and a sea-side restaurant. On a steep hill overlooking the sea stood the Lutheran church with its parsonage, and on a small island connected to Brändö lay the community cemetery shaded by tall birches where fallen soldiers were buried along with the rest of Brändö's former citizens. Two idealistic spinster sisters had founded the co-educational school that Maj was longing to get back to and that I had yet to attend.

There was only one tall building on Brändö then, and that was the stately four-story white brick apartment building, Domus, where Nunni and Lale rented a third-floor apartment. Domus, in their opinion, had everything their family would need: ample space with all the necessary shops on the street level: a grocery store and a butcher shop, a bank, a post office, a drug store, a florist, and a stationery store. The tram to Lale's job in Helsinki passed right by the building, and opposite it was a park that became a skating rink in the winter. And best of all:

at the back of Domus, next to the schoolhouse, was the forest, crisscrossed by footpaths in the summer and cross-country ski trails in the winter—a paradise for picnics and games. Brändö was an independent municipality, where everybody knew everybody else and where, when the inevitable happened and Helsinki incorporated it into the city proper in 1946, all our parents stood up at midnight when the law went into effect, hoisted their Champagne glasses and uttered a resounding swear word in unison.

Artists, academics, and originals of every stripe lived on Brändö, as well as entrepreneurs and businessmen. One of the largest villas belonged, for a time, to the Fabergé family, the grandson of the Tsar's jeweler, who had fled the revolution in St. Petersburg in the nick of time. Their son, Oleg, was an only child and Riikka occasionally took Maj over to play with him. One of Mannerheim's closest generals, General Heinrichs, lived on Brändö too, and could be seen, every day, taking his constitutional around the island, his eyes staring into the distance, his hands clasped behind his back. Sometimes he would cross paths with a colleague, the General of the Artillery, Vilho Petter Nenonen, whose ability to correctly calculate trajectories had put the fear of God into the Russian troops. The composer and choral director Heikki Klemetti lived in a smaller villa surrounded by a yellow fence; my friends and I sometimes stood outside and sang, in order to inspire him. A few houses from the composer was the house and studio of the deaf and brooding sculptor Wäinö Aaltonen, whose statue of the legendary long-distance runner Paavo Nurmi, the Flying Finn, now stands outside Helsinki's Olympic Stadium.

Finland's first President, Kaarlo Juha Ståhlberg, who defeated Mannerheim in the election of 1919 and who was one of the main drafters of our constitution, also lived on Brändö with his mild-mannered and gray-haired wife, Esther. He was a frail man whose small apple orchard was one of our favorite destinations

when my friends and I went on apple snatching expeditions on dark fall evenings. There was something mysterious about the Ståhlbergs: in 1930, the two of them had been kidnapped by members of a right-wing movement, who intended to spirit them off to the Soviet Union as part of an attempted fascist coup d'état. They never got that far—in fact, the kidnapping attempt went a long way to discredit the movement itself, which was outlawed in 1932. It gave the popular Ståhlberg an aura of prestige without, however, protecting his apples.

<p style="text-align:center">℺</p>

While I waited in Luleå and thought about Brändö, there was *Stina's World News* to keep up. In February 1945, the big news was the Yalta Conference; the World News had a banner headline over its four columns, and it was accompanied by my drawing (copied from a real newspaper article) of the Big Three— Prime Minister Winston S. Churchill, President Franklin D. Roosevelt, and Premier Josef Stalin—busy trying to decide what to do with Germany. *World News* also pointed out that I had a new pair of shoes, all leather, but there was no mention of the fact that at this very time, the Allies were also busy creating firestorms in German cities and reducing Hamburg, Dresden, Cologne, Essen, Freiburg, and Dortmund to ruins, including large parts of Berlin and Munich.

<p style="text-align:center">℺</p>

My sister had wanted an airplane for Christmas 1944, so she could fly back home. She'd even threatened to bike back. She had used all her persuasive powers to try to convince Lale that it was high time for us to return. The war in Finland was over, so what were we still doing in Luleå? She missed the world we had left even more passionately than I, and as she got news that many of her friends were returning to Brändö and that school had started again, she became desperate. She cried herself to

sleep at night. Things reached a point where Lale, pondering what to advise his family, had to take his eldest daughter's mental state into consideration. And to add fuel to the fire, an extra edition of *Stina's World News* arrived in Lale's mailbox from Luleå, with an editorial pointedly stating that "people who have been evacuated are now returning home."

CHAPTER TWELVE

From All Evil Things He Spares Them

"THANK YOU, my darling, for your New Year's letter," Lale wrote from Helsinki in early January 1945. "It feels so good to know that I have someone who is thinking of me and who shares my feelings. This whole holiday (it's felt like a surrogate Christmas) my thoughts have been with you and the children every single moment. How I long for the day I will see you and the girls again—may God grant that it won't be too long. I'm in good spirits, and a voice tells me that all this is just a short interlude—during which time our love has grown even deeper—and that we will still have many long and happy years ahead of us."

And he added: "Otherwise, things are pretty quiet here. The Communists, however, are working hard behind the scenes. We'll have to see how many votes they'll manage to get in the elections and what they'll do if they don't get a sufficient number of votes as they see it. But until the elections are over and the new parliament is in place and we can see in what direction things are going, you'll just have to put up with staying there, no matter how bitter you may feel about it."

In addition to her other worries, Nunni was concerned about our living situation. Since so many apartment buildings had been bombed, and there were so many refugees and war veterans to house, there was a severe housing shortage in Helsinki. To help matters, the government had declared that every

intact apartment had to house a certain number of persons, although some might be perfect strangers. Kitchens over a certain size were also considered as rooms where someone could sleep. Would Nunni and Lale have to have a perfect stranger, or a family of strangers, sharing their apartment? Lale told her not to worry: "When you return home, we'll be five people here including Riikka, and since Totti and Mummo (Lale's brother and his mother-in-law) are here, we will be positively crowded. In addition, I have gotten a notice saying that Grandma Nanny has the right to come and live here, so don't worry, we won't have to take in any strangers." Grandma Nanny did indeed move in shortly after that, and then continued living with us for many years.

Food continued to be in short supply: "They had potatoes in the grocery store (you had to have coupons) yesterday, for the first time this year! Mummo bought some, but a good third of them were spoiled." He urged Nunni to send small containers of artificial sweeteners, "cheap there, but very sought after here, and can be used as barter," and sewing thread. "And start to buy socks for yourselves, and yarn to darn them with," he told her. He mailed her a package of newly made traditional Finnish jewelry, stamps, and a Swedish-Finnish dictionary for my mother to sell for travel money.

"A great deal of work at the Ministry," my father wrote. "The firewood situation for the railroads is very difficult and the forest industry will have to provide some pulp in order to keep the trains going in February. I have been given the unenviable task of calculating how much each paper mill will have to give up as a 'loan.' I'll have to work all day tomorrow, although it's Sunday, and then I think I'll go to a movie in the evening."

Meanwhile, Nunni had a new housing problem in Luleå to deal with. The wife of the family my sister Maj had moved to, Ida, was showing signs of regret. She claimed the girls were not getting along, but Nunni suspected the real reason was political.

Even before Maj had moved in, Ida had made her political sym-
pathies clear: all future good things were going to come from the
East, from the new Bolshevik world order. Ida's sister had lived
under Nazi occupation in Norway, married to a Norwegian.
Naturally, she hated the Germans, and since Nunni couldn't
muster any enthusiasm for the Russians, Ida had concluded that
our family was pro-Nazi. Nothing could have been further from
the truth, but Nunni wisely decided it was time for Maj to move
in with her at the refugee camp. "As far as the Russians go, time
will tell who is right," she wrote to my father.

<center>☙</center>

The Finnish Parliamentary elections were now over. There was
a record turnout: 74.9 percent of the people had voted in the
first election held since the beginning of the war in 1939. Three-
fourths of the Parliament's 200 new members represented the
three largest parties, the Agrarians, the Social Democrats, and
the People's Democratic League. The new left-wing group that
included the Communist Party received forty-nine seats. A gov-
ernment was formed, headed by Juho Kusti Paasikivi who had
been the chief negotiator during the peace talks with the Rus-
sians in the spring of 1944 and who was to become Finland's
President after Mannerheim resigned in 1946. My father must
have considered all this fairly reassuring, because my parents
now started making plans for us to return home from Sweden.
My mother had managed to save up for our travel, and with the
repatriation of the Finnish refugees from Lapland in full swing,
her job, along with the refugee camp itself, was being phased
out. "I wonder what it'll feel like to be 'a civilian' once again,"
she wrote. "I'm so happy that the work with the refugees will be
over soon—I really haven't had a free moment since I came from
Finland. Perhaps now I have done my part for a while and have
earned the right to relax a bit."

The mayor of Luleå certainly agreed that she had done her
part, and more. He sent her a letter of appreciation, praising her

work in glowing terms. "I'm ashamed to even show it to any-
one," Nunni wrote. "The Swedes are so polite."

"How very nice that you no longer have to shoulder the
heavy responsibility of the refugee camp," my father concurred.
"I personally think and hope that the conditions will be such
that I can risk bringing you all home. We can't know anything
for certain, at least not as long as the war reparations have not
been paid in full—in six years time, that is—but I suppose one
has to tolerate some sort of risk. I don't think there is any par-
ticular danger of anything happening in the near future. Our
food situation won't be easy for sure, the potato situation will be
iffy, but we should be able to muddle through somehow. Don't
lose touch with the Ylitornio people, maybe we can get potatoes
from them! Eat well, as long as you are there, and bring plenty
of food with you!"

<p style="text-align:center">℘</p>

On April 12, 1945 the radio reported that President Franklin D.
Roosevelt had died, and *Stina's World News* hurried out an extra
edition with the additional news that Roosevelt had been suc-
ceeded by Harry S. Truman. On April 25, the last German troops
left Finnish territory and three days later General Siilasvuo de-
clared his Lapland mission complete. The Twentieth Mountain
Army with all their supplies would never enter the war on the
Continent: the Red Army had reached Berlin on April 21, and
the final cataclysmic battle of Berlin was already raging.

Nunni now started packing everything Lale had sent us: our
skates, our skis and poles, our bike. Into wooden crates it all
went: our clothes, our books and journals, our pots and pans,
my doll and my stuffed dog. We had good reason to rush: since
the bridges to Finland had been destroyed, we needed to leave
while the ice covering the border river was strong enough to
carry us in a car across to the Finnish side.

<p style="text-align:center">℘</p>

As the Nordic spring approached, the Finnish refugees in Swe-
den—some 56,000 of them—were clamoring to return home.
A small number of refugees had returned as early as January.
After the last German soldiers had crossed the border into Nor-
way on April 25, 1945, the Swedish authorities had their hands
full trying to prevent full-scale defection from the camps before
Finland was ready to receive them. They knew, and the Finn-
ish border authorities knew, that many of them had nothing to
return to. The roads and the areas around their ruined homes
and villages were bristling with mines that needed to be cleared.
Arrangements had to be made to feed the returning refugees.
But in April and then all through the summer and fall, streams
of refugees were returning home. The Red Cross, the American
Friends Service Committee, and the United Nations sent relief
workers to Lapland, and the Swedes also assisted with personnel
and supplies. They lent buses and trucks and donated temporary
barracks for the returnees to live in. They even provided shelter
for the returning livestock—one of Uncle Axel Elgstrand's final
tasks as head of the Center for Finnish Livestock. A blackened
chimney poking into the sky where their house had once stood
greeted the majority of returning refugees. It was a matter of
starting from scratch. There was a shortage of everything: ce-
ment, bricks, nails, roofing materials, glass for windows. Saws
were buzzing night and day, and people were combing through
ruins for usable bricks and nails. Time was of the essence. The
refugees needed a roof over their heads before a new Arctic
winter set in. The repatriation was not always orderly: many of
those who had learned that their homes had survived—people
who had lived in isolated homesteads or in communities that
the Germans had left in a hurry—simply took off on their own
from the Swedish camps. In June, the Lapland roads were again
full of refugees and cattle, this time heading east. Some of the
railroads were still usable, and by September, almost exactly a
year after they had left, most of the refugees from Lapland had
returned.

This was a busy time for Uncle Axel. He orchestrated with utmost care the arduous return of the animals, over provisional bridges and on makeshift ferries and pockmarked roads. Sixty years later, in the Stockholm War Archives, I marveled at his thoroughness. Every single animal that had been one of "his troubles" in Sweden had its date of repatriation entered on a file card.

ᔕ

"So," Brita said with a knowing smile as we were leaving school one day. "I'll see you in Sunday school."

"No, you won't," I said, not trying very hard to hide my satisfaction. "My father says that the war is over. We are going home." I thought of my picture of the field of daisies. It still had many gaping white spots. They would remain empty. "We are going home in three days, Brita."

After class, I told my teacher, a very kind lady. She seemed genuinely sorry I was leaving, and said the whole class would come to see me off at the railroad station.

"But we are leaving very early," I said, overwhelmed at the thought. "So that we can get over to the Finnish side before it gets dark." Nunni had explained the whole thing and it sounded very easy to me.

"We'll be there anyway," my teacher said.

And on that morning, there they were, my whole class, gathered on the platform in the morning darkness as we arrived with all our things. The teacher asked for a moment of silence and said:

"We wanted to come and wish you and your family all the best for your journey back home. We wish to sing a song for you, but first we want to give you this as a remembrance of your time here in Sweden."

She handed me a small velvet box. Inside was a delicate silver heart on a thin chain, with an inscription: "Stina, Luleå, April 21, 1945."

It was the first piece of jewelry I had ever owned.

"Now, children," my teacher said and raised her arms. "Let's sing for Stina and her family." As the locomotive was puffing warm-up clouds of white steam into the chilly morning air, the little cluster of classmates turned their faces toward me and sang my favorite hymn:

Children of the heavn'ly Father
Safely in His bosom gather
Nestling bird nor star in heaven
such a refuge e'er was given.

God his own doth tend and nourish,
in His holy courts they flourish.
From all evil things He spares them,
in His mighty arms He bears them.

Neither life nor death shall ever
from the Lord his children sever;
unto them His grace He showeth,
and their sorrows all He knoweth.

Though he giveth or He taketh,
God His children ne'er forsaketh;
His the loving purpose solely
to preserve them pure and holy.

છ

As my classmates were singing the last stanza and I was contemplating what depth of curtsy would be appropriate for the Lapp King's daughter, I noticed another girl on the platform, right next to my mother.

"This is Ulla Emaus," my mother told me after we had said goodbye to the teacher, the class, and Uncle Axel. "She is com-

ing with us back to Helsinki." Then the train whistled and we clambered aboard and my classmates on the platform in their bulky winter coats got smaller and smaller.

I had not met Ulla before, but she was my age and during that long trip down the length of Finland back to Helsinki we sat together, sensing a bond that we could not put into words. Much later, she told me her story.

When the bombing of Helsinki had intensified in 1943, Ulla's mother had decided, after much hesitation, to let her only child join the child transports to Sweden. Actually, because she was deeply conflicted about sending her daughter away, she had decided to leave the final decision up to the six-year-old.

"Do you want to go to Sweden?" her mother had asked. Like me, Ulla had a very clear concept of "Sweden." In Ulla's imagination, you got there by ascending a wide staircase, with a landing. On that landing, a beautiful woman was playing the piano. Ulla didn't hesitate for one moment: she wanted to go to Sweden. And all of a sudden, she was on her way, her mother on the platform, waving, and she on the train with hundreds of other bewildered children with nametags around their necks.

The train reached Tornio three days later. Ulla was lucky. The Russians had hit a similar train with the same Red Cross symbols painted on the roofs. Several children had been killed.

This was in February. Ulla got sick on the journey and ended up in a Swedish hospital with scarlet fever. Her mother had to wait for six weeks to receive any news from her.

❧

A month after our return home, my mother sat down at her typewriter and wrote a letter to Axel Elgstrand in Luleå:

"I want to briefly tell you about our journey home. A car met us in Haparanda on the Swedish side and took some of our boxes; the rest was to go by train to Tornio. Things were gray, gray on the Finnish side in Tornio! At the City Hotel we

could only get one room with two beds, and no extra bedding.
I took the paper sheets from the beds and put the mattresses on
the floor, and that's where the children slept. Riikka and I slept
on the beds with a paper-thin mattress and we used our coats
as blankets. Sometimes our feet were freezing, sometimes our
shoulders. Outside, the rain was pouring down and I thought
about our boxes out in the rain at customs in Haparanda and
hoped that the thoughtful Swedes would throw a tarp over them
or carry them inside somewhere. The driver who drove us from
Haparanda to Tornio promised to come back on Sunday morn-
ing and bring my boxes to Tornio. But that night, his mother
died. A new chauffeur showed up, a fifteen-year-old boy who
had no idea about anything! After lots of searching we finally
found our things and at 2:15 we set out from Tornio down to
Kemi in a car loaded with all our stuff. The boy turned out to be
a very skillful driver and really competent. At first, the road was
fine. Here and there, we could see wrecked cars and tanks. We
crossed over rickety provisional bridges and passed lots of burnt-
down houses. But closer to Kemi, the road became almost im-
passable. The small car was dancing like a nutshell on a stormy
sea. They had placed a "bridge" across the Kemijoki River di-
rectly on the ice. That bridge consisted of a lot of sawdust on the
river ice and boards that the car had to balance on! Our car kept
slipping off the boards, now the left wheels and now the right,
it's a miracle that we did not have a flat. After a tremendous
push we reached dry land on the other side and continued on a
somewhat better road. And then we passed through a thorough-
ly ruined area. Farmhouse after farmhouse was burned down
and the only thing you could see were chimneys and ruined
walls against the gray sky. Stina and Ulla counted the 'fires' and
when they had reached fifty, Ulla shivered and said: 'I think I'll
turn around.' I told her it wouldn't be like that in Helsinki, and
she calmed down. We made it to Kemi in good time, and I let
out a sigh of relief when all our things and we ourselves were on

board the train. I made provisional beds for the children and they slept until six o'clock the next morning. The sun came up and the rails were singing, home, home—and we reached Helsinki only half an hour late."

∞

On the platform, beaming at us in the throngs of people milling around the half-ruined railroad station, stood the Lapp King himself. He had kept his promise. He had not come home from the war in a wooden coffin. He had kept our apartment safe. He had steered the Russians away from us, and now he would keep them from invading our country. He had spared us from all evil things. So why then, I wondered after he had given me and my sister a strong hug each, why then was my mother crying as he took her in his arms?

Epilogue

A WEEK AFTER we returned from Luleå, on April 30, 1945, Hitler committed suicide in his bunker in Berlin. On May 7, the German forces surrendered to the Allies. The fighting in the Pacific continued until the Americans dropped the atomic bombs over Hiroshima on August 6 and on Nagasaki on August 9, 1945. On August 15, the Japanese signed a document of unconditional surrender. World War II was over.

❧

It would take forty years before I first heard the term "developing country," but that was essentially what post-war Finland was. Malnourishment was rife, especially among the young, and small children with swollen bellies were not uncommon in the 1940s and even into the 1950s. Rickets, diphtheria, and gastrointestinal diseases took their toll as food rationing continued through 1949, and thousands of war widows struggled to keep their families going.

Lale had been right: life would be bleak. Gone were the days of Swedish chocolate: now we feasted on dried carrots sweetened with saccharine or candy made of beets. There were shortages of everything. If you saw people standing in line, you rushed to join them and only then did you ask what the queuing

was about. You could forget about buying almost anything liquid unless you brought an empty bottle along. There was much joking about these empty containers. I remember Lale coming home once after standing in line for something. He had asked what people were lining up for, and someone had said: "Bananas. But you have to bring the empty peels." In 1948, 20,000 children could not go to school because they didn't have any shoes. Clothes, and material from which to make clothes, were in short supply. We had to sacrifice our living room curtains so that my sister could get a new jacket and skirt, and I continued to wear my old grayish-brown shoes with wooden soles and paper uppers to make the new leather ones from Luleå last longer.

UNICEF started work in Finland, and at one time, surplus U.S. military food and other supplies were available. I remember the rectangular tins of corned beef as a great delicacy. Lale bought a large surplus U.S. military tent and made a platform for it; that became my "house" on the island where we spent our summers. Relief packages from Sweden and the United States, containing condensed milk, raisins, and dried fruit were much coveted. American toothpaste was so good you could eat it as a sweet. Pea soup and gruel and, the next day, fried gruel, perhaps with home-made lingonberry jam, was the order of the day, interspersed with generous portions of cod liver oil.

But Finland still had a Control Commission, and a Minister of the Interior, Yrjö Leino, who was a Communist and did the Soviet's bidding. In 1945, Prime Minister Paasikivi was urged by the extreme left to bring Finland's "war criminals"—those who had been in positions of authority during the war against the Soviet Union—to justice. People were indignant, but something needed to be done to placate the Russians. There was a tacit agreement to leave Mannerheim out of it, which put the former President Ryti in an even more precarious position. He was not able to claim that Finland's military command had acted inde-

pendently from the Germans during the months preceding the Continuation War.

The trial was concluded in February 1946, with Ryti condemned to ten years in prison. He and his co-defendants were seen by the Finns as national martyrs and subsequently completely rehabilitated. When the political pressure from the left diminished after the elections of 1948, Ryti was given amnesty and he was freed in 1949. His health, however, had suffered greatly, and he never returned to public life.

Finland continued to pay heavy war reparations to the Russians until 1952. The sum of the reparations, $300 million, was the largest any country paid after the Second World War in relation to the number of inhabitants, but it also forced Finland to repair its industrial base in short order, and thus get on its feet once again. Miraculously, the country had escaped postwar occupation. But for decades to come, Finnish foreign policy followed a line of strict neutrality and "friendship" vis-à-vis the Soviet Union, in order not to provoke its mighty neighbor in the east.

Finland's transformation from a largely agrarian economy on the fringes of Europe, from a country that had lost one tenth of its territory and that had to resettle four hundred thousand refugees, to one of the most affluent members of the European Union has been dramatic and swift. Fifty years ago, over a million Finns lived off the land; now, only about one hundred thousand do. Empty farmsteads everywhere stand mute witness to the depopulation of the Finnish countryside, particularly in the north and the east, as urban centers grow. Today, as a result of smart educational policies and an emphasis on industries such as electronics, the modern welfare state of Finland bears little resemblance to the country where I grew up and where my parents struggled during the three wars of their generation.

❧

How my parents coped during those war years, I do not know. But now they were finally together again, and didn't have to communicate by letters. Their pent-up longing for each other and their happiness about being reunited was evident every day: they never left for work or returned from their jobs at the end of the day without a kiss and a hug. Nunni thrived in her job as a teacher of physical and health education at our local school, and also became its vice principal. Lale continued his work on behalf of Finland's forest industry, and played a crucial role in getting this sector of the Finnish economy back on its feet after the war. An honorary doctorate from Helsinki University and a medal from the King of Sweden—the very same King for whom my sister had acted as translator when we lived in Luleå—are testimony to the high esteem in which he was held.

During summer vacations on our island, my parents pursued their hobbies: Nunni painted and made delicate pen and ink drawings and tinkered with our outboard motor; Lale did carpentry and planted and cared for wildflowers he had gathered from all over Scandinavia. Our wanderings during the war years receded in our minds. We hardly ever talked about them.

My sister Maj entered art school after her high school graduation and became an internationally known clothes designer, eventually founding a prominent work-wear company with a woman colleague. She married a young man from Brändö with whom she had three sons. Eventually, these sons married and produced nine lovely grandchildren, most now living near her Brändö home.

Grandma Nanny continued to live with us for a few years after the war, and eventually moved to a small town west of Helsinki to be close to her daughter, my Aunt Majsi and her husband, Helge, and their three children. Lale's brother, Uncle Totti, and his family continued to be part of our lives, as did Aunt Biggi and Uncle Bert and their two sons.

Riikka was an important part of our family, and when my

sister married and had her three boys, those boys were given piggyback rides on Riikka's back. She continued baby-sitting for them as long as her strength permitted. During her final years, she lived in an old age home not very far from where my parents had moved when I, too, married and moved away.

To no one's surprise, the Lapp King's daughter herself moved much farther. My wanderlust was evident from early on. At the beginning of my last year in high school, our graduating class of ten sat around writing down predictions for our future lives. There was unanimous consent about my future: I would marry a "dark man" and move away from Finland. After graduating from the University of Helsinki and working in print and radio journalism, I spent a year in the United States, then two years doing social work in Peru, then another three years in Lebanon where I met my Armenian husband, Herant. We moved to California in 1966 when he joined the Department of Psychiatry at Stanford University. In due time, our children Nina and Kai were born.

Nina and Kai, against all odds, came to know Nunni and Lale well, because we continued spending our summers on the island in Finland, a place where every rock and tree and crevice and piece of shore carries memories of their grandparents. Here is the rock where Nunni used to cut Lale's hair. Here is where Nunni sat when she made the drawing of the shore. Here is where we used to help Lale crush peanuts for the birds, and there is where Nunni used to grill fresh Baltic herring over juniper. When Nina heard the news that Lale had passed away on a beautiful day in July, 1976 at the age of 77, she cried: "So who will now tell me the names of all the flowers?"

Nunni, who visited us in California many times, survived Lale by thirteen years. During those years, she often brought up the subject of the letters I was to read one day.

"Just think of them as a greeting from us," she said, with a smile.

CHRONOLOGY

1155–60 Bishop Henry's mission to Finland on behalf of the Catholic Church to Christianize the pagan Finns starts the Swedish chapter of Finland's history.

1323 Treaty of Pähkinäsaari establishes the border between Sweden and Russia.

1527 King Gustav Vaasa of Sweden adopts the Lutheran faith.

1700–21 Great Northern War between Sweden and Russia; Russia occupies much of Finland. Conflict ends with the Treaty of Turku in 1743; some territory ceded to Russia.

1809 After a bloody war launched by Tsar Alexander I, Sweden cedes Finland to Russia. Finland becomes a Grand Duchy under the Tsar, who confirms and ratifies the country's religion and fundamental laws.

1863 The Finnish language is declared equal to Swedish in all matters directly concerning the Finnish-speaking population.

1890–1905 Period of increasing Russian attempts to curb Finnish autonomy. The Russian Governor-General Bobrikov is given dictatorial powers and is assassinated in Helsinki by the student Eugen Schauman in 1904.

1906 The Parliament Act establishes a unicameral legislature of 200 members, elected by both men and women. This makes Finland the second country in the world, after New Zealand, to give women the vote.

Oct., 1917	The Communists seize power in Russia.
Dec. 6, 1917	Finland declares its independence.
1918	The brutal Finnish Civil War breaks out between the working-class Reds and the White government troops led by ex-Imperial Russian army officer Mannerheim. The Whites, reinforced by volunteers from Sweden and German-trained officers, eventually win.
Aug., 1939	The Nazi-Soviet non-aggression pact includes a secret protocol that assigns Finland to the Soviet sphere of influence.
Oct., 1939	The Soviet Union presses Finland for territorial concessions. The talks break down. We leave Helsinki for Vaasa as war seems imminent.
Nov. 30, 1939	The Red Army attacks Finland and the Winter War against the Soviet Union breaks out.
Dec., 1939	We leave Vaasa for the village of Petsmo.
March 13, 1940	Moscow Peace Treaty.
March, 1940	We return to Helsinki.
June, 1940	The Soviet Union occupies all of Estonia. The country is named one of the Soviet Socialist Republics.
June, 1941	We leave Helsinki for Vaasa and Malax; Lale stationed on the Hanko Peninsula (Hangö).
June 22, 1941	Germany attacks the Soviet Union. Finland remains neutral.
June 25, 1941	Soviets bomb Finnish cities in retaliation for Finns allowing Germans to attack from Finnish territory.
June 26, 1941	President Ryti declares Finland to be at war, but claims it is fighting a separate war from its co-belligerent, Germany.
July, 1941	The Germans conquer Estonia and keep it until it is retaken by the Red Army in 1944. The country remains under Soviet occupation until May, 1990, when it proclaims its independence.
Oct., 1941	We return to Helsinki. Lale is stationed in the East.

June 4, 1942	Marshal Mannerheim's 75th birthday, at which he reluctantly hosts Hitler. Mannerheim is given the honorary title of Marshal of Finland.
Jan. 31, 1943	Germans surrender in Stalingrad. Finns begin to be convinced Germany will lose the war; start thinking of how to make peace with the Soviet Union.
Feb. 6, 1944	First large-scale bombing of Helsinki; we flee to Aunt Biggi's outside Helsinki.
June 9, 1944	Large-scale Soviet attack on the Karelian Isthmus.
June, 1944	We flee to northern Finland, to a farm in Ylitornio. Lale in Helsinki.
June 25, 1944	Battle of Tali-Ihantala, largest battle ever fought in the Nordic Countries, starts.
Aug. 4, 1944	President Ryti resigns. Marshal Mannerheim is nominated to the Presidency.
Sept. 4, 1944	Cease-fire between Finland and the Soviet Union.
Sept. 19, 1944	Interim peace treaty between Finland and the Soviet Union.
Sept. 22, 1944	First members of the Allied Control Commission arrive in Helsinki. Across the Bay of Finland, the Soviets take Tallinn, the capital of Estonia.
Sept. 28, 1944	First battle breaks out in Lapland between Finns and Germans.
Oct. 3, 1944	We cross the border river to Luleå, Sweden.
April 27, 1945	The last German troops withdraw to Norway.
April 27, 1945	We leave Luleå and return to Helsinki.
1947	Peace Treaty of Paris.
1952	Olympic Games in Helsinki.
1995	Finland joins the European Union.

BIBLIOGRAPHY

Books:

Ahto, Sampo. *Aseveljet vastakkain. Lapin sota 1944–1945.* Helsinki: Kirjayhtymä, 1980.

Anon. *Soldatbrev från Finlands krig, 1939–1940.* Helsingfors: Söderströms & co. förlagsaktiebolag, 1940.

Ehrnrooth, Adolf. *Generalens testamente.* Helsingfors: Söderströms Förlag, 2004.

Ekberg, Henrik. *Finland i krig, 1940–1944.* Del II. Esbo: Schildts Förlags Ab., 2000.

Ihrcke-Åberg, Ingalill, ed. *Minnen från krigstiden.* Svenska Litteratursällskapet i Finland, 2005.

Franck, Anne-Marie. *Lilla syster. Finlands Röda Kors hjälpsystrar under fortsättningskriget.* Schildts Förlags Ab., 1998.

Hiilivirta, Kaija, ed. *Sota ja evakuointi Pohjoiskalotilla 1944–1945.* Rajakuntien kulttuuriyhteistyön työryhmä, 1995.

Jacobson, Max. *The Diplomacy of the Winter War: An Account of the Russo–Finnish War, 1939–1940.* Cambridge, Mass.: Harvard University Press, 1961.

_____. *Finland Survived: An Account of the Finnish–Soviet Winter War 1939–1940.* Helsinki: Otava Publishing Co., 1984.

Jägerskiöld, Stig. *Från krig till fred: Gustaf Mannerheim 1944–1951.* Helsingfors: Holger Schildts Förlag, 1981.

_____. *Gustaf Mannerheim 1867–1951*. Helsingfors: Holger Schildts Förlag, 1983.

Jermo, Aake. *Kun kansa eli kortilla*. Helsinki: Otava, 1974.

Junila, Marianne. *Kotirintaman aseveljeyttä. Suomalaisen siviiliväestön ja saksalaisen sotaväen rinnakkaiselo Pohjois–Suomessa 1941–1944*. Bibliotheca Historica: 61.

Kaila, T.K. *Kriget i Lappland*. Helsingfors: Söderström © Co Förlagsaktiebolag, 1950.

Kavén, Pentti. *70.000 små öden*. Finlands krigsbarn: Sahlgrens, 1985.

Kungliga Krigsarkivet. *Flyktingärenden, spridda handlingar*. Stockholm. D XI vol. 1–18B; D XII:3; F VII, vol. 11–14, 17–27, 48–49; F IX.

Lähteenmäki, Maria. *Terra Ultima. A Short History of Finnish Lapland*. Helsinki: Otava Publishing Company, 2006.

Linder, Jan. *Finlands fyra krig*. Avesta: Infomanager Förlag, Svenska Tryckcentralen AB, 2004.

Rautio, Erkki; Korteniemi, Tuomo; and Vuopio, Mirja. *Pohjoiset pakolaiset. Tietoa ja tarinoita Lapin sodasta ja lappalaisten evakkotaipaleelta*. Pohjan Väylä, 2004.

Tikkanen, Anja. *Lapin evakot*. Hämeenlinna: Arvi A. Karisto Osakeyhtiö, 1975.

Voss, Johan. *Black Edelweiss: A Memoir of Combat and Conscience by a Soldier of the Waffen-SS*. Bedford, Pennsylvania: The Aberjona Press, 2002.

Wendisch, Irja. *Tohtori Conzelmannin Sotavuodet Lapissa*. Helsinki: Ajatus Kirjat, 2002.

Wuorinen, John H. *A History of Finland*. New York: Columbia University Press, 1965.